THE ESSENTIAL ™
René Magritte

BY TODD ALDEN

THE WONDERLAND
PRESS

Harry N. Abrams, Inc., Publishers

THE WONDERLAND PRESS

The Essential™ is a trademark
of The Wonderland Press, New York
The Essential™ series has been created by The Wonderland Press

Series Producer: John Campbell
Series Editor: Julia Moore
Project Manager: Adrienne Moucheraud
Series Design: The Wonderland Press

Library of Congress Catalog Card Number: 98-074612
ISBN 0-8362-1936-8 (Andrews McMeel)
ISBN 0-8109-5803-1 (Harry N. Abrams, Inc.)

Distributed by Andrews McMeel Publishing
Kansas City, Missouri 64111-7701

Unless caption notes otherwise, works are oil on canvas

Printed in Hong Kong

Harry N. Abrams, Inc.
100 Fifth Avenue
New York, NY 10011
www.abramsbooks.com

Contents

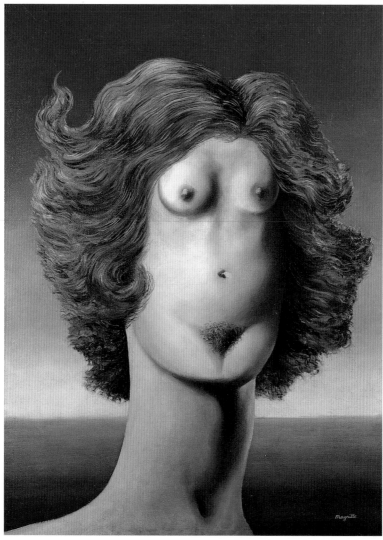

The False Mirror

OPPOSITE
The Rape. 1934
73 x 54"
(184 x 136 cm)

Imagine this: You're out for a walk one afternoon and you notice the powder-blue sky dotted with puffy white clouds. Suddenly it feels like midnight, even though it's only 3:00 PM, and when you look up, there's hanging above you—oh jeez!—is a 20-ton boulder with a castle on top of it! Hundreds of bowler-hatted men float through the air, accompanied by a band of flaming tubas. *Let's get out of here!* You race back to your house, screaming for help...and there's a 600-lb. green apple in your living room! You streak down the hall and are sideswiped by a train charging out of the fireplace. What's going on here?

Welcome to the world of René Magritte. You recognize the apple, the bowler-hatted men, the train, and the massive boulder. *But why are these familiar objects in such unfamiliar places?*

René Magritte (1898–1967) is not a household name, as is his fame-obsessed fellow Surrealist, **Salvador Dalí** (1904–1989), but almost everyone has seen Magritte's uncanny, strangely familiar images. Many of us recognize Magritte not through his art but through the presence of his images in ads used to sell virtually everything from compact discs to credit cards. In 1952, the CBS television network transformed Magritte's *False Mirror* (on the next page) into the eye of its still-recognizable corporate logo, and imitators have followed suit

5

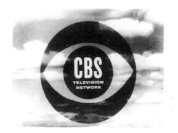

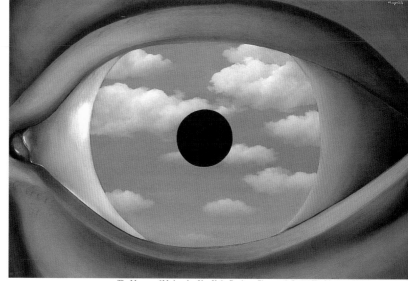

ever since. But if, to paraphrase the artist, this is not the essence of René Magritte, then who *is* the essential Magritte?

The Enchanted Domain

This book will help you look squarely into the Belgian Surrealist's idiosyncratic eyes and penetrate to the **unique vision** that makes him the most accessible and durable of all the Surrealist painters. Magritte's appeal is relevant and universal because his dreams have the power to awaken the viewer to the silent splendor of the *real world* and to its enduring mystery. So, for a few moments, trash your television and throw away your credit cards, and let's explore **Magritte's secret passage into an enchanted domain.**

Who *was* René Magritte?

Magritte was a deeply private man, and when he did speak about his past, he was often provocative, cryptic, and befuddling, as in his art. Some artists, such as **Jackson Pollock** (1912–1956) and Dalí, lead "glamorous" lives that fill pages of popular magazines; but others—such as René Magritte and **Edward Hopper** (1882–1967)—connect with their viewers almost exclusively on the canvas. *It's their work, not their life, that grips us and changes the way we view the world.* So let's find out who Magritte was, then have fun with his work so that the next time you're in a museum, you'll know more about Magritte than anyone there.

What gives in his Paintings?

The great thing about Magritte is that *his paintings draw us in.* They puzzle and intrigue us, but they also disturb us. Whether they're **"words-and-images"** paintings or **painted bottles** or **gouaches** (*gouache* is an opaque, water-based paint often used to make studies for larger works on canvas; it is easier to manipulate than oil paint) or **collages** (a form of art where various materials not normally associated with each other, such as newspaper clippings, bits of thread, theater tickets, etc., are pasted onto a single surface) or the dozens of **oil paintings** that form the bulk of his oeuvre, Magritte's works are puzzles—enigmas—that invite multiple interpretations.

Unlike Surrealists who delved into the murky realms of the unconscious, Magritte sought to create **lucid images.** Put off by the interpretation of his paintings as *dreams,* he pointed out in his many writings that *his* paintings—unlike those of other Surrealists—were clear and accessible. He consciously crafted an intellectual world of "dreams that are *not* intended to make you sleep but to wake you up." Even his titles reinforce the enigmatic quality of his paintings: Magritte's friends were mostly poets and he would often sit around with them, making a Surrealist game of inventing titles that were more poetic than "explanatory"—thus, the titles reflect his affinity to poetry rather than to descriptive captions and usually have nothing to do with the physical subject of the painting.

ABOVE
Magritte behind
Signature in Blank
1965

Duane Michals (New York)

LEFT
Signature in Blank
1965
31 ⁷/₈ x 25 ⁵/₈"
(81 x 65 cm)

The Man with the Bowler Hat

OPPOSITE
The Schoolmaster
1955

Magritte preferred a suit, a collared shirt, and a tie to the usual paint-splattered smock adopted by artist-bohemians. For most of his life, he lived in a middle-class household in Brussels, Belgium (bourgeois capital of Europe), painting in his living room rather than renting an art studio. Yet Magritte defied conventionality at every turn. A man of many guises, he was a painter, writer, thinker, chess player, graphic designer, ad-man, magazine editor, Charlie Chaplin-lover, occasional Communist, anti-Fascist, infrequent traveler, classical music buff, and avid pulp mystery reader.

But who *is* this man in the bowler hat, really? **René-François-Ghislain Magritte** is born on November 21, 1898 *(a Scorpio!)* in a white, one-story house in Lessines, Belgium, a homesite now occupied by a red-brick freight building. The eldest of three brothers—the other two being **Raymond** (1900–1970) and **Paul** (1902–1975)—René is baptized into a lower-middle-class Catholic family, the son of **Léopold Magritte,** a hardworking tailor, and of **Régina Bertin-champ** (c. 1870–1912), a milliner.

Sound Byte:

"It is perhaps childhood that comes closest to true life."

—ANDRÉ BRETON, in the first *Surrealist Manifesto*

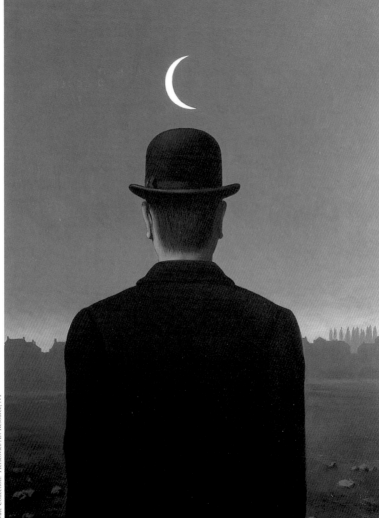

Magritte's Scrapbook: Missing Memories

When Magritte is about a year old, his family moves from Lessines to the small Belgian town of Gilly. (For unexplained reasons, the family will move often for the next eleven or twelve years. This may account for the missing photos, which no one has ever explained.) It is in Gilly that Magritte experiences the first of a series of bizarre childhood events that later produce vivid memories, a subject in which the Surrealists take great interest. After a large hot-air balloon unexpectedly crashes onto his rooftop, two balloonists, dressed in leather and helmets, suddenly appear before him in the stairwell of his house, dragging a deflated balloon down the stairs. This *surreal* encounter imbues Magritte for the first time, he later recalls, with "the sensation of mystery." (The Magrittes move out shortly thereafter.)

Aside from a few such snippets of childhood memories, Magritte has little to say about his early years. The truth is, the secretive artist does not like to talk about the troubled aspects of his childhood. Here, though, are a few additional snapshots of Magritte's first ten years:

- **He lives in various Belgian towns** where the working

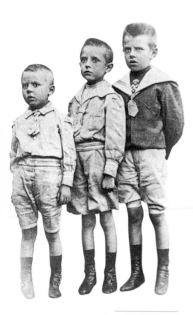

Magritte, on the right, with his two younger brothers Paul and Raymond c. 1905

population consists largely of steelworkers, miners, and glass-factory workers. In 1904, the family moves to Châtelet.

- **He uses a pen name,** "Renghis, Detective" (a shortening of his Christian name: *Ren*é-François-*Ghis*lain), in his first written works, detective stories. Clearly the young Magritte already has a penchant for disguise. (The stories subsequently disappear, never to be published.)

- **He spends his vacations with his grandmother** and Aunt Flora at Soignies (no two places in tiny Belgium are far apart).

- **He likes to dress up as a priest,** holding mock masses in earnest before a self-made altar (and presumably finding *mystery* in the Roman Catholic ritual).

Portrait. 1923
17 x 14 ¹/₄."
(43 x 36 cm)

Quiet Boy, or…Curmudgeon Next Door?

In 1910, at the age of 12, Magritte attends his first painting classes, which are held on Sunday mornings above a candy store in Châtelet. As the only boy in the class (or as Magritte puts it, "the sole representative of male humanity in the ad hoc studio"), he is, well, like a

kid in a candy store, studying painting as well as the fine art of umbrella-stand decoration.

Most accounts of Magritte's childhood say nothing about his early temperament, other than to suggest that **he was a quiet boy.** There are indications that his family might have been dysfunctional and that, if indeed he was a quiet boy, then at least a part of him was already a curmudgeon, as revealed by his later attraction to "systematic provocation." Though it is rarely mentioned, his mother suffers from depression.

As a youngster, Magritte delights in neighborhood pranksterism, such as hanging cats on the doorbells of respectable citizens. Belgium's old-fashioned pull cords allow you to do this without hurting the feline too much: You merely wrap the pull cord around the cat's legs, causing the bell to ring and ring and ring when the cat wriggles.

For Reasons that Remain Unexplained...

One of the most disturbing events of Magritte's life occurs on February 24, 1912. His depressed mother throws herself off a bridge into the Sambre River in the middle of the night. (It is not her first suicide attempt.) According to Magritte's handpicked historians, René and his two brothers, upon noticing her absence, set out to look for Régina in the dark of the Belgian night. It is said that the brothers discover her almost completely naked corpse with her wet nightdress pulled up over her face like a shroud. The truth, however, is that her body is missing almost three weeks before it is discovered on March 12, when **she is found with her nightdress pulled above her head.** Later in life, Magritte makes the rather unbelievable statement that it is impossible to say whether his mother's death had any influence on him or not. One does not have to believe in Freudian psychoanalysis (as the Surrealist Magritte, curiously, did not) to challenge his wishy-washy denial of the extent of the impact of his mother's death. The fact of her suicide—not to mention seeing her naked body—must have had an unspeakably traumatic effect on his 14-year-old psyche.

A Morbid Result

The big question is: How much did her suicide influence Magritte's art? Since Magritte refused to talk about it or admit to its impact, it's difficult to know. It is important to respect the complexity of the

Surrealist's aesthetic intentions and to resist the temptation—which some critics do not—to regard this event as the master key that opens all the locks to Magritte's psychic vault or, worse yet, that explains the symbolic order of his paintings. (With Magritte's "hooded figures," which we'll get to, it is hard to disagree entirely with the critics.) Let's say this: We won't be in over our heads if we suggest that Régina's suicide and the discovery of her half-naked body are the most conspicuous influences on the formation of the sensitive Magritte's identity.

> **FYI:** **Morbida**—Magritte recalls that the suicide brought him some schoolhouse notoriety with schoolmates, who anointed him "the boy whose mother killed herself." Magritte loved to play in graveyards as a child and nurtured a keen fascination for the morbid—an interest that is evident in his motifs of fragmented body parts, female corpses, coffins, gravestones, and the like. Check out *The Balcony of Manet* on page 59.

Magritte at age 16

An Age of Anxiety

In 1913, the Magrittes move to Charleroi, where, in the absence of his depressed mother, Magritte is raised by his grandmother and a governess. In 1914, three months before he turns 16, the Germans occupy Belgium for the first time. After the invasion, the Magrittes move back to their home in Châtelet. Two years later, in 1916, Magritte begins

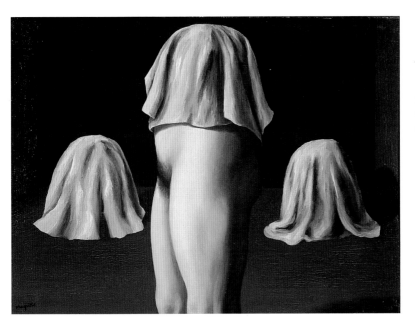

The Symmetry Trick. 1928
21 ¹/₄ x 28 ³/₄"
(53.55 x 72.45 cm)
Giraudon/Art Resource, NY

his first serious artistic study at the prestigious Académie des Beaux-Arts (Royal Academy of Fine Arts) in Brussels. But art school's conventional classes on aesthetics and history leave him bored, and there are indications that **he cuts classes at the Academy.** What does conventional beauty matter when your mother is dead, your country is occupied, and the most brutal war in history is well under way? For Magritte, the choice is fairly obvious.

BACKTRACK:
WORLD WAR I (July 28, 1914
to November 11, 1918)

The times they were a-changin', and fast. The nightmare of WWI brought Europe four turbulent years of bloody conflict—and unprecedented social and political upheaval after it was over. WWI was the first "modern" war, and it brought atrocities previously unimaginable. Machine guns, tanks, air raids, gas and trench warfare left millions of people dead, senselessly. In France, ten percent of the active population was lost. Mutilated survivors, saved by modern medicine, became highly visible reminders of the horror and displacement brought on by the war. *It was not a pretty picture.*

After a number of moves between Brussels and Châtelet, Magritte remains in Brussels in April 1917 and proceeds to paint his **first commercial poster,** an advertisement for *Pot au Feu Derbaix,* which is released in 1918. By 1919, he is publishing drawings in the journal *Au Volant,* and in early 1920, he exhibits his poster designs at the Centre d'Art, founded by his friends Victor and Pierre Bourgeois.

Two influences on Magritte's early painting are **Cubism** (the movement co-developed in France from 1907–14 by Pablo Picasso and Georges Braque in which natural forms are reduced to their geometric equivalents) and **Futurism** (a literary and artistic movement developed in Italy from 1910–16 by the artists and poets Umberto Boccioni, Filippo Marinetti, and Gino Severini that expresses violence, power, speed, mechanization, and hostility to the past and to traditional forms of expression, and replaces the old forms with the "new beauty" of machines and, especially, motion).

He dabbles in the other *-isms* of avant-garde art, too, but it's not essential to get into the nitty-gritty distinctions among all of them. The bottom line is that his relation to each of these modern movements shares

the following essential characteristics:

- **Abstraction:** He experiments with objects that appear in varying degrees of recognizability, but that are rarely completely abstract.

- **Brushwork:** He employs visibly loose brushwork, including the technique of *impasto* (the build-up or thickening of paint on the surface, as in Van Gogh's paintings). Contrast this early brushwork and its thick, swirling, opaque surfaces to his later, more transparent, lean, "polished" surfaces.

- **Space:** Surfaces are flat, forms are unmodeled (or crudely modeled) and lack illusionist perspective or the illusion of depth that will appear in works after 1925.

- **Subject matter:** Magritte sticks to the conventional subjects of landscapes, portraits, and nudes.

Love Comes to Town: 1920

Things start to look up for Magritte in 1920. Seven years earlier, he had met **Georgette Berger** (1901–1986), his future wife, on a carousel at the Charleroi town fair. Now, in 1920, he runs into her by chance in the botanical gardens in Brussels, where he has moved a couple of years earlier. The 19-year-old Georgette, a bourgeoise at heart (her later taste in home furnishings, Magritte admits, is typically middle class), is a strikingly beautiful, artsy teen who works at the Coopérative Artistique with her sister. The day of this chance meeting, Magritte is accompanied by his longtime friend and the future Surrealist impresario, **E. L. T. Mesens** (1903–1970), whose interest in avant-garde music and composition will bring him (and later Magritte) into contact with the Paris Surrealists. (Magritte had first met Mesens in 1920 when the latter was giving piano lessons to Magritte's brother Paul.) Unlike the French Surrealists, the Belgian Surrealists do not shy away from the pleasures of music.

> **FYI: Magritte and Music**—Magritte's taste in music is generally not avant-garde, (nor did he like jazz), but rather middlebrow. His modest record collection includes works by Bach, Brahms, Haydn, Mozart, Beethoven, Wagner, and Tchaikovsky. After their marriage, the Magrittes rarely attend public concerts, but Georgette sometimes plays for René on their baby grand piano.

In the Army: 1921–22

Having spent a detested ten months in the army in 1921 in Brussels, Antwerp, Leopoldsburg, and at a camp near Aachen, Germany, Magritte paints little during this year besides a few portraits of officers. Once free from army obligations, **he and Georgette marry on June 28, 1922** in Brussels, where they will remain for the rest of their lives, except for three years in Paris. In summer 1922, they move into a rented apartment for which Magritte designs much of the furniture. (The groom is an excellent carpenter.)

Magritte and Georgette at the time of their marriage, 1922

> **FYI:** Georgette will serve as the model for most of Magritte's paintings of women, usually nude. Although she may seem idealized in the paintings, she in fact possesses a radiant, movie-star beauty. Georgette and René have no children (Georgette will keep canaries and the couple will share a Pomeranian named **Loulou)** and remain deeply devoted to each other, inseparable even, until Magritte's death.

Magritte supports himself during these lean years, first by taking a job in late 1921 as a wallpaper designer at

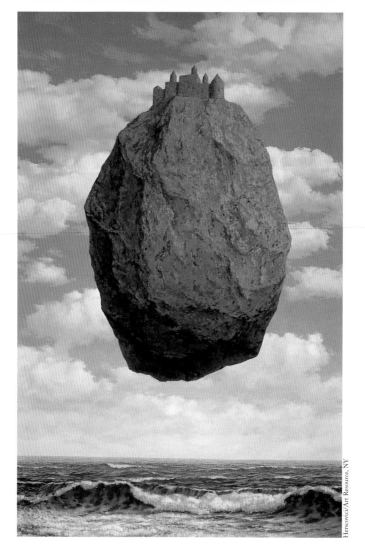

the Peters-Lacroix wallpaper factory, then, after finding the factory "as unbearable as the barracks," by "doing idiotic jobs: posters and publicity designs."

Magritte's Magical Mystery Tour

Magritte is not, as it is often said, a painter of slumbering dreams. His are eye-opening visions, lucid dreams that plumb the depths of the invisible while exploring the world of hidden and concealed things—a world, Magritte felt, that most people do not see because they are unwilling to open their eyes. **Magritte's dreams seek to wake up and provoke the viewer's disturbing secrets,** and to issue an invitation (to those who dare) to enter an enchanted domain, to discover a nether-world of mystery.

OPPOSITE
The Castle in the Pyrénées. 1959
79 x 55"
(31.35 x 21.83 cm)

Sound Byte:
"The word dream *is often misused concerning my painting. We certainly wish the realm of dreams to be respectable—but our works are not oneiric* [about dreams]. *On the contrary. If 'dreams' are concerned in this context, they are very different from those we have while sleeping. It is a question of self-willed 'dreams'—'dreams' that are not intended to make you sleep, but to wake you up."*

—MAGRITTE

Understanding Magritte is sometimes difficult because he intentionally frustrates stable, rational thought. A paradox-loving master of contradiction, Magritte is the Confucius of Confusion. We really start to *get* Magritte when (1) we accept that **his images are constructed like a hall of mirrors** that have no fixed, anchored meaning; and (2) when we begin to hear the silence of his world and start to **feel the mystery of the unknown.**

Smells like Dada Spirit: Writing and Publishing

As you've probably guessed by now, Magritte is known as a Surrealist painter. But before Surrealism becomes the major force in his work, he is influenced by the Dada movement, to which he is introduced by his friend E. L. T. Mesens around 1923. It is Mesens who has connections to the Paris Dadaists (the core of whom establish the Surrealist movement), whom Mesens meets through the avant-garde composer **Erik Satie** (1866–1925). Through this connection, Magritte and Mesens contribute some witty aphorisms in 1924 to the last issue of the important Dada review, *391.* The publishing activities of the Paris Dadaists and Surrealists inspire them to cofound *Oesophage,* a late Dada-esque review, in 1925, followed by *Marie,* "a bimonthly paper for beautiful people" (of which only three issues are published). Shortly thereafter, Mesens and Magritte join poets **Paul Nougé** (1895–1967) and **Marcel Lecomte** (1900–1966) and art dealer **Camille Goemans** (1900–1960), director of the first gallery in Paris to show

Surrealist painting, in a venture to publish yet another monthly review, *Correspondence.* Most of these men will become a part of Magritte's life-long circle of friends.

From the ruins of Dada, Magritte and his pals give birth to Belgian Surrealism in late 1926, an occasion that is heralded by three collectively signed texts. Even more than the Dadaists, the Surrealists are passionate about publishing reviews and 'zines. These forms allow them to distribute their **message of shock,** and later of **revolution,** in a made-for-the-masses format. Magritte takes from Dada its *provocative attitude* and *absurdist, anticonventional spirit.* This unorthodox spirit will flow through his veins, and thus his art, for the rest of his life.

Sound Byte:
"The beginnings of Dada were not the beginnings of art, but of disgust."
—TRISTAN TZARA, poet

Poetic Painting

Dada and Surrealism do not find expression in Magritte's painting until 1925, after Magritte falls under the spell of Max Ernst, and especially of **Giorgio de Chirico** (1888–1978). If Dada's rejection of traditional painting contributes to Magritte's revolutionary attitude, then it is

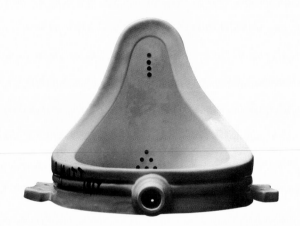

Marcel Duchamp, *Fountain.* 1917
Porcelain plumbing fixture and enamel paint, *24 ⁵/₈" high (62.23 cm)*
Philadelphia Museum of Art

Dada was a movement of artists and poets in the early 1920s—first in Zurich, then later in Paris, Berlin, New York, and elsewhere—who revolted against traditional forms of art, such as easel painting. While mocking the technological "advances" of a smug bourgeoisie, the Dadaists produced "anti-art" that focused more on what it was *not* than on what it *was*. Using provocation as a deliberate aesthetic strategy, they protested against bourgeois values and against the turbulent disorder brought about by World War I. Marcel Duchamp's *Fountain* is a good example of Dada art: It's a men's urinal signed, spuriously, "R. Mutt." Major Dada figures included artist **Marcel Duchamp** (1887–1968), poet **Paul Éluard** (1895–1952), photographer **Man Ray** (1890–1976), and poet **Tristan Tzara** (1896–1963).

The literary and artistic movement of **Surrealism** began in about 1922 in Paris as an outgrowth of Dada. Led by the French poet and theorist **André Breton** (1896 –1966), the Surrealists pursued the "true functioning of the mind" (Breton's words) by lodging a "lawsuit against reality." All the Surrealist leaders—Breton, Éluard, and novelist **Louis Aragon** (1897–1982) among others—were twenty-something poets and veterans of World War I who had been profoundly affected by the war; all had been members of the French Dada group until 1922. The seeds of Surrealist revolt and its distrust of rationalism were sown during the age of anxiety, World War I. Surrealism was a more grown-up version of Dada protest that sought to *provoke* in order to build a new social and aesthetic order. Surrealism turned away from Dada's largely negative aesthetics and tone in favor of a more positive search for "the new society."

The Surrealists sought to unleash the instincts and impulses of the unconscious mind by means of ***automatic writing*** and painting (which Breton called *pure psychic automatism)*, whereby the artist bypasses his/her conscious willpower and lets unconscious impulses guide the hand in matters of line, color, and structure, without rational or planned "interference." The movement was more suited to writers than to artists, since the free flow of impulses could be channeled more quickly onto the page than onto a canvas. Besides Magritte and Duchamp, major Surrealists included artists Salvador Dalí, **Yves Tanguy** (1900 –1955), **Max Ernst** (1891–1976), and film director **Luis Buñuel** (1900 –1983).

Historians generally give Surrealism a shelf life of 1924–47, the period between World War I and World War II. Breton presided as the Surrealists' controversial chief spokesman in a sometimes dictatorial style, organizing exhibitions and promoting Surrealist invention internationally until his death. In 1924, he wrote the first *Surrealist Manifesto*—the declaration that formally initiated the Surrealist movement—pledging allegiance to "the superior reality of certain forms of association heretofore neglected, in the omnipotence of dreams, in the undirected play of thought." Breton's purpose was also ethical: He believed that if people could wake up to their unconscious thoughts and to the world of the imagination, they could change their lives and the world, too. The first person to use the word *Surrealism* was the French poet and art critic **Guillaume Apollinaire** (1880 –1918) in a short program note written in 1917 for Diaghilev's production of the ballet *Parade,* a production whose collaborators included composer Erik Satie, choreographer **Léonide Massine** (1896 –1979), and **Pablo Picasso** (1881–1973), who designed the set and costumes. Surrealism found expression not only in painting, but in 'zines and reviews, photography, and, most importantly (the Surrealists hoped), in everyday life.

BACKTRACK:
GIORGIO DE CHIRICO
(1888–1978)

Italian painter of illusionistic "metaphysical landscapes" that juxtapose the classical world with contemporary motifs. In *The Song of Love* (1914), for example, the head of a classical statue hangs next to a modern surgeon's rubber glove, nailed to a wall. De Chirico's work looks Surrealistic because of such pairings of incongruous elements and his discombobulated use of perspective. He is not, however, a Surrealist. De Chirico falls deeply out of favor with the core Surrealists after he turns to academic painting; but Magritte's admiration never falters. He sometimes refers to the Italian simply as "Chirico."

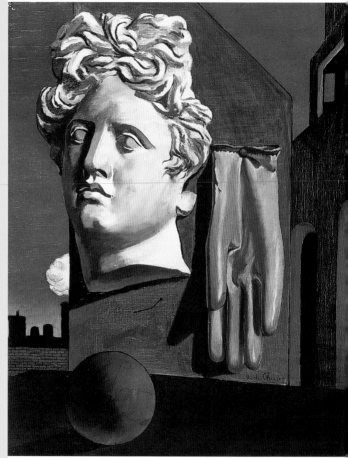

de Chirico who gives Magritte "triumphant poetry, a new vision through which the spectator might recognize his own isolation and hear the silence of the world." By his own account, Magritte is moved to tears when, in 1925, a friend shows him de Chirico's painting, *The Song of Love*.

Sound Byte:
"A friend then showed me a reproduction of his painting, The Song of Love, *which I always consider to be a work by the greatest painter of our time in the sense that it deals with poetry's ascendancy over painting. Chirico was the first to dream of what must be painted and not how to paint."*

—MAGRITTE

De Chirico's influence on Magritte leads him to **focus on poetic content in his paintings** (the juxtaposition of the incongruous, for example) instead of on painting's formal problems. It also moves him to **adopt de Chirico's illusionistic style** and to depict recognizable objects. Magritte's use of this illusionistic style goes against the fashionable trends in modern painting, which, from the teens until Abstract Expressionism in the late 1940s, emphasize the evolving languages of abstraction. (Jackson Pollock said, *If you want to see a face, go look at a face.*) It is not until the rise of Pop Art in the 1960s that there is a full-fledged return to the *object* (think Andy Warhol's *Campbell's Soup Cans*) and that fashion catches up with Magritte.

OPPOSITE
Giorgio de Chirico
The Song of Love
1914
28 3/4 x 23 3/8"
(73 x 59.1 cm)

Surrealism is an Enigma Wrapped in a Riddle

Okay, by now you get the point: Surrealism can be bewildering stuff, a kind of enigma wrapped in a riddle. Magritte and the Surrealists love games, and we're rewarded if we let ourselves play with the limits of the visible and the knowable. But we must always remember that it's the haunted, enchanted domain of mystery that interests Magritte. His magical mystery tour is dying to take us away. Ready?

OPPOSITE
The Domain of Arnheim. 1962
57 ¹/₂ x 44 ⁷/₈"
(145 x 113 cm)

Bowler Hats Everywhere

Magritte, the man, is a walking contradiction: While deliberately and systematically provoking scandal in his works, he seeks to remain inconspicuous in his everyday appearances. For Magritte, the bowler hat that he wears until his death—a symbol of the bourgeois Everyman—is reminiscent of the mask worn by his favorite pulp novel anti-hero, Fantômas. It is a prop that conceals his identity beneath the guise of everyday life.

Sound Byte:
"He is a secret agent. His object is to bring into disrepute the whole apparatus of bourgeois reality. Like all saboteurs, he avoids detection by dressing and behaving like everyone else."
—GEORGE MEALLY, scriptwriter for the film
"René Magritte, Middle-Class Magician" (1965)

The Masterpiece, or The Mysteries of the Horizon
1955

Although tempting, it is inappropriate to equate the bowler-hatted men in Magritte's paintings with the artist himself, even though, like Magritte, the bowler-hatted man's face is almost always turned away from the viewer, his thoughts forever unknown to us. Observer of the world, he is a modern version of the solitary Romantic poet, contemplative and in tune with the silence of the world. By turning the man away from us, Magritte invites the viewer to wear the subject's hat, to identify with his gaze upon the mysteries of the horizon, and to create the image and meaning that are generated by our own imagination.

For his entire career, Magritte fills his paintings with men wearing bowler hats, which are commonplace, essential accessories in every middle-class gentleman's wardrobe of the 1920s and 1930s. But the bowler becomes old-fashioned as time passes. It has come to serve as a trademark, however, of Magritte's mythic presence, just as the blond wig has for Andy Warhol.

A Transitional Year: 1925

Magritte's first breakthrough comes in 1925 with *The Window* (see page 34), which he describes as his "first painting." It is, in fact, very de Chirico and shows Magritte beginning to abandon abstraction in favor of de Chirico's illusionistic style, as well as painting "objects only with their visible details." What is fresh and interesting about this work, comparatively speaking, is its odd juxtaposition of a severed hand and a fluttering bird. Notice also the abstract elements—the colorful

The Window
1925. 25 x 20"
(63 x 50 cm)

triangular sphere, for example—that typically appear in paintings during this transitional year. Though he has almost achieved the full Surrealist voice that will last an entire career, Magritte is not quite there. He paints 60 some canvases (not including collages and drawings) in the years 1925–26. Although he states that "in the art of painting, as I perceive it, technique plays only an incidental role," the truth is that Magritte is not yet the skillful painter he will become by mid-1928. His earliest works—many of them painted at the rate of one a day—show his inexperience, as with the loosely modeled figures (e.g., the hand in *The Window*) that appear amateurish in comparison with the strongly focused images of his later, more "polished" pictures. It's not until 1926 that he makes what he considers his first successful Surrealist work, *The Lost Jockey*.

Sound Byte:
"So I decided, around 1925, that from then on, I would only paint objects with all their visible details."

—MAGRITTE

The Lost Jockey

The Lost Jockey—shown in the collage version here—is, in Magritte's eyes, his first "successful" Surrealist work, since its gains power from a *poetic idea* rather than from technical virtuosity. It is in this work that

The Lost Jockey
1926
Gouache collage
15 $\frac{1}{2}$ x 21 $\frac{3}{8}$"
(39.3 x 54 cm)

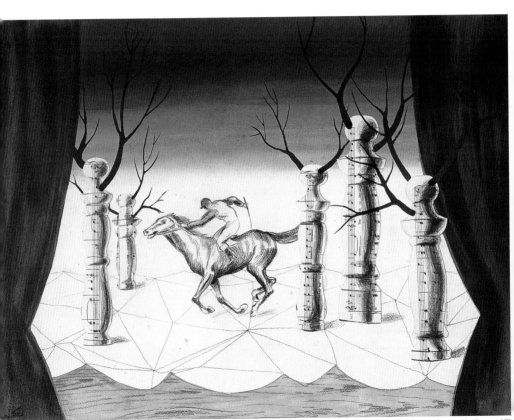

Magritte discovers a sense of mystery and the unknown, and he will return to the theme of *The Lost Jockey* many times throughout his career. Pasted on top of the paper's surface are bizarre shapes cut out of sheet music that resemble a combination of forms, such as chess pieces and the legs of a table turned upside down, creating a bizarre unity of incongruous elements. (Like Marcel Duchamp, the godfather of Dada and Surrealism, Magritte is passionate about chess, though not as skilled at it as Duchamp.) One of the lyrics in the collage reads "Sprechen sie Deutsch, mein Herr?" ("Do you speak German, Sir?"). Lost along with the jockey, the viewer is struck with that eerie sensation aroused by so many of Magritte's subsequent pictures: *Let's scram!*

> **FYI: Collage**—Surrealists loved creating collages. Although Magritte does not make a large number of collages during his career—he produces a dozen or so between 1925 and 1927 and a sporadic smattering thereafter—what is important is his use of the *principle of collage,* the idea of cutting up familiar forms, juxtaposing or rearranging them in a new, mysterious way, a principle that characterizes virtually his entire output of paintings.

Suddenly Everything Clicks: 1926

In 1926, Magritte signs a contract with the foremost art impresario of Brussels, **P.-G. Van Hecke** (1887–1977), that guarantees the purchase

of his output. This vote of confidence and the financial stability it represents redoubles Magritte's sense of purpose. From here on, he hits his stride. During the four years (1926–30) that Magritte is under contract to Van Hecke, he produces 280 oil paintings—a quarter of his lifetime output in this medium, averaging about one work every six days. While Magritte is creating at this extraordinary rate, Van Hecke attempts to build a market for his art, but has only occasional success.

Au Revoir, Brussels....Hello Paris!

Magritte gets his first one-artist exhibition in 1927 with Van Hecke at Galerie Le Centaure, Brussels. The critical response to his 49 oil paintings and dozen collages is mostly hostile. But this does not deter him and Georgette from packing their bags and taking a shot at the big time—Paris—headquarters of the Surrealists.

In September 1927, the Magrittes rent a fifth-floor apartment at 101, avenue de Rosny in Le Perreux-sur-Marne, just east of Paris. His brother Paul joins them, renting an apartment nearby and singing in neighborhood piano bars.

The year 1928 is a tumultuous but prolific one for Magritte, who produces more than 100 paintings (most of which are not exhibited until years later). It is also the year in which:

- **His father dies** on August 24th of a stroke back home in Brussels.

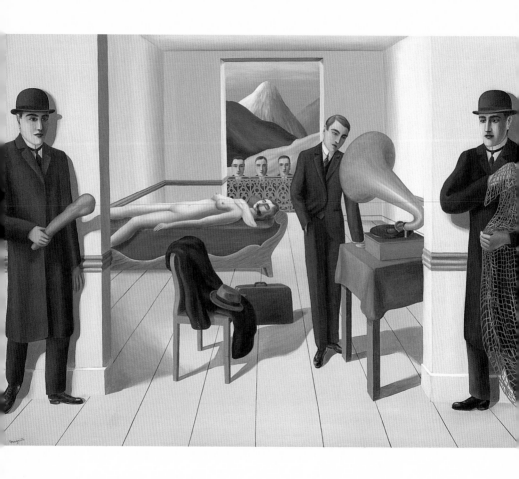

The Museum of Modern Art, New York. Kay Sage Tanguy Fund. Photograph © 1999 The Museum of Modern Art, New York

The Menaced Assassin is one of Magritte's first masterpieces.

Narrative: Two virtually identical-looking men wearing bowler hats (the device of "doubling") lie in wait for the killer with a limblike club and a net. Meanwhile, three other identical-looking men (doubling again) spy through the window at the killer, who has turned his back on the naked, bloody body of his victim, a woman lying on a sofa. The killer's hat, his coat (casually draped over a chair), and a valise suggest a disguise, or imminent getaway. But why is the killer listening to the Gramophone with such apparent detachment? (Wouldn't you love to know what song he is listening to?) Will he escape? Are the menacing pursuers *really* after the assassin or is this an imaginary scene depicting the killer's inner conflict?

Light: The bright light cast upon the killer and his pursuers contrasts with the dark, sinister (not to mention erotic and necrophilic) undertones of this painting: Like the notion of the "uncanny" itself (see text on page 41), Magritte sheds light (literally and figuratively) on some things that we might prefer had remained hidden.

Confinement: Magritte's composition of receding planes (walls in the foreground and background) intensifies and focuses the drama of confinement and entrapment.

Effect: Like a morbid Rorschach test, Magritte invites the viewer to make up the story for himself, leaving us without answers. Narrative uncertainty—which Magritte plays upon so expertly and so often —pushes us into the disquieting domain of fear and dread.

Pop culture: Magritte's sources of inspiration are often drawn from popular culture. *The Menaced Assassin* is highly reminiscent of *Fantômas*, a popular series of French pulp crime novels that feature a popular anti-hero, Fantômas (see page 40), whose criminal hijinks Magritte and other Surrealists hold in the highest regard. A man of infinite disguises, Fantômas always manages to outwit the police, invariably escaping at the last possible moment and freeing himself from the most precarious situations.

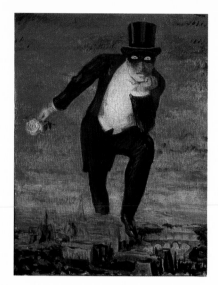

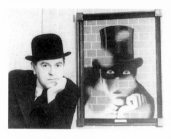

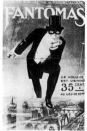

Fantômas: Magritte expresses his fascination with the character of Fantômas in numerous paintings, although the pictorial references are almost always altered in some way. One exception is The Return of the Flame, in which Magritte more or less copies a Fantômas novel's dust jacket featuring the character of the same name. Magritte is so fascinated by this character that, in 1928, he publishes his own dramatic scenario of a Fantômas encounter in a Belgian Surrealist review. Writing about Fantômas, Magritte says, ""He is never entirely invisible. One can see his portrait through his face. When memories pursue him, he follows his arm, which drags him away. His movements are those of an automaton; he brushes aside any furniture or walls that are in his way. We do not guess, and we cannot doubt his powers."

- **Magritte is omitted from two major Surrealist events** in the spring of 1928: He is excluded from André Breton's book, *Surrealism and Painting,* and from Breton's important Surrealist Exhibition in Paris.

- **Breton changes his mind about Magritte** later in the year. When Breton buys several of Magritte's paintings, the artist becomes a card-carrying member of the Paris Surrealist Group.

The Search for Disturbing Poetic Effect

Magritte's "systematic search for disturbing poetic effect" bears a striking resemblance to Sigmund Freud's investigation into the *uncanny.* In a 1919 essay, Freud defines the *uncanny* as a realm of aesthetics that pertains not to a *theory of beauty,* but rather to a *theory of feeling*—in particular, to the feelings of repulsion and distress. (Forget for a minute that Magritte is sometimes critical of Freudian psychoanalysis. Freud, who is central to the germination of Surrealist thought, has little patience himself for the Surrealists.) "The uncanny," Freud writes, "is that class of the terrifying that leads back to something long known to us, once very familiar"—in other words, something that is once hidden, but that subsequently, and disturbingly, comes to light. *Sound familiar?* Freud's examples of uncanny things read like a laundry list of Magritte's disturbing pictorial imagery: doubles, automatons, the return of the dead, dismembered limbs, a severed head, a hand cut off at the wrist, things that suggest "doubts whether an apparently

animate being is really alive, or, conversely, whether a lifeless object might not be in fact animate." Finally, Freud notes that "an uncanny effect is often and easily produced by effacing the distinction between imagination and reality." It is this concept of the uncanny that best describes the aesthetic field and poetic operations of Magritte's endeavors.

How does he create Optical Illusions?

This use of optical illusions (which the French call *trompe l'oeil)* forms the basis of Magritte's style, known as *Surrealist illusionism.* He creates optical illusions by using such pictorial techniques as perspective, foreshortening, and modeling that try to **deceive the eye** into accepting the painted image as a real image. He uses the simple method of making the familiar unfamiliar in order to provoke surprise and invite the unexpected. **He isolates objects out of context,** as with "a Louis-Philippe table on an ice floe"; **he juxtaposes elements that don't generally go together,** such as a flaming tuba (see page 45); he deforms or modifies the substance of things, such as a woman without a head or feet that double as a pair of boots (see page 44); and **he changes the scale of objects and their usual relationship to their contexts,** as with a giant green apple that fills an entire room (see page 104).

Unlike Surrealists such as Dalí, who paint seemingly incoherent dream worlds, Magritte creates a universe that is almost always recognizable

The Magician
(aka *The Sorcerer*)
1951. 12 x 17 ¹/₂"
(35 x 46 cm)

RIGHT
The Red Model
1935. Gouache on
paper, 19 x 22 ¹/₂"
(48 x 57 cm)

OPPOSITE
*The Discovery of
Fire.* 1934–35
13 x 16 ¹/₄"
(33 X 41 cm)

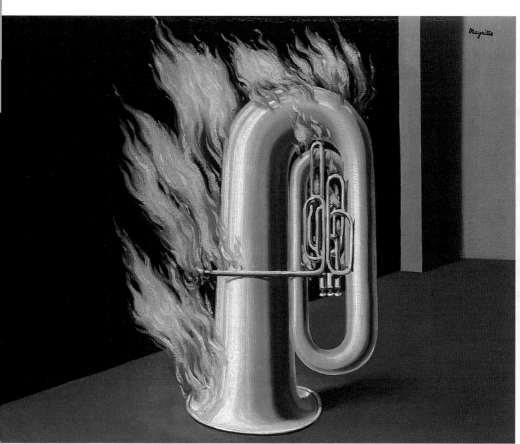

Magritte

as our own. He presents familiar objects—an apple, a window, a pipe, a suitcase—but transforms them into something mysterious and unfamiliar. **His spaces are shallow and have simplified backgrounds.** The picture's depth is deliberately interrupted with horizontal planes that deny the viewer a "safe distance" from the work. Inspired by the directors of *film noir*, he employs bright lights and harsh shadows to suggest the dark and sinister, or to imply the unknown and mysterious.

One of Magritte's most fascinating techniques is to crop and fragment compositions through the use of "scissors," or **the placement of an internal frame:** It's as if he inserts a framed painting into the actual painting itself and thereby heightens the dislocation of both the object and the viewer's perception of the image.

Sound Byte:
"Given my attention to make the most everyday objects shriek aloud, they had to be arranged in a new order and take on a disturbing significance. A female body floating above a town was a distinct improvement on the angels who never appeared to me."

—MAGRITTE

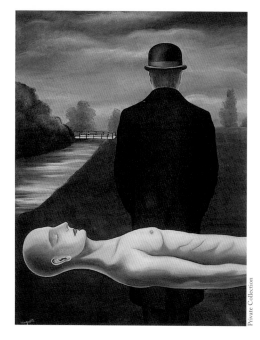

*The Musings of a
Solitary Walker*
1926. 55 x 42"
(139 x 105 cm)

Only Darkness has the Power

There is an extraordinary darkness in Magritte's paintings from the
period 1926–36. One of the first appearances of a bowler-hatted man
in his paintings can be found in *The Musings of a Solitary Walker*. The
man faces away from the viewer, but that doesn't prevent us from see-
ing the naked body (corpse?) of an emaciated woman, her head
strangely shaven, her lips unnaturally rouged. Is she really levitating

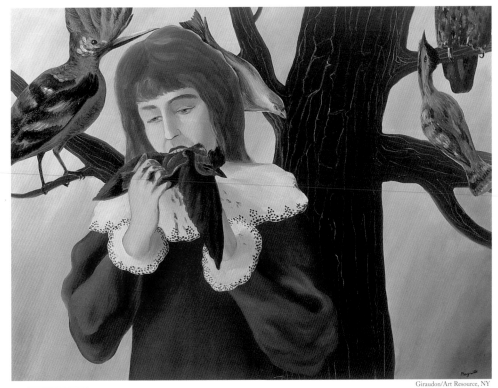

Giraudon/Art Resource, NY

*Young Girl Eating
a Bird.* 1926
29 ¹/₂ x 39 ³/₈"
(74.34 x 99.04 cm)

under a dark, rainy sky near a river and a bridge? How can we not think of this picture, along with Magritte's Freudian critics, in the powerfully dark light of his mother's suicide by drowning? Notice the disquieting and piercingly disturbing mood and uncertain narrative. What's going on in this painting, anyway? Is she dead or alive? And what are we to make of the confusing title, *The Musings of a Solitary Walker?*

Girl Eating a Bird

Young Girl Eating a Bird has the morbid, uncanny atmosphere of the darker tales and poems by Edgar Allan Poe, whom Magritte admired tremendously: Within sight of other birds, a clean, blonde, "proper" girl dressed in lace rips open the body of a freshly killed bird with her teeth. Notice:

- **The jarring contrast** between the "civilized" girl (she's wearing lace) and her animalistic dining manners. (Is she *really* chewing on the raw flesh of a freshly killed bird?)

- **The background** is foreshortened by a white, foglike mist. Magrittean space is almost always shallow, close-up, and confining. This effect confronts the viewer, denying us a safe distance.

- **The pictorial fragmentation:** Magritte's close cropping of the image serves to break "its ties with the rest of the world in a more

or less brutal or in a more or less insidious manner" (Magritte).

- **Magritte's paint handling,** frankly, is at times still a little rough. Notice the almost sloppy job on the holes making up the girl's lace or the almost clumsy way Magritte paints her hand in a flat, unmodeled tone.

Contrast his paint handling here with that in any painting made after mid-1929, when the work becomes dramatically more polished. Not surprisingly, this quality coincides with an abrupt decrease in the quantity of his output and a temporary increase in collector interest.

Hooded Figures: 1927–30

Among his most haunting series of paintings are the hooded figures. Produced between 1927 and 1930, they reflect his intrigue with disguise and secrecy. In *The Symmetry Trick* (see page 17), a hood conceals the top part of a naked female torso, provoking nervous questions in the minds of the viewer, now a participant, whom Magritte cagily has drawn into this morbid game of hide-and-seek gone terribly wrong. What is the symbolic meaning of these truncated, hooded figures that frighten us? What, exactly, is being hidden? Why are the otherwise postcardlike figures in *The Lovers* covered with those menacing hoods? Do Magritte's hooded figures redress—in some unspeakable way—the artist's childhood trauma of seeing his mother's wet nightdress pulled up over her dead body? We can only

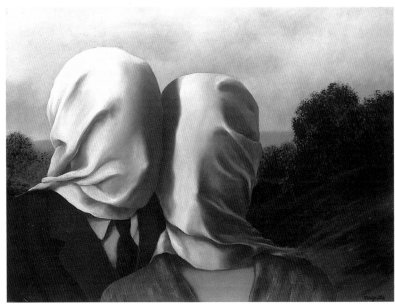

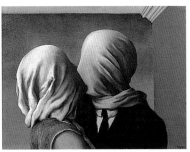

TOP
The Lovers II
1928. 21 ¹/₂ x 29"
(54 x 73 cm)

National Library of Australia
Canberra, Australia. Giraudon
Art Resource, NY

BOTTOM
The Lovers. 1928
21 ¹/₂ x 29"
(54 x 73 cm)

Richard S. Zeisler Collection
New York

state with certainty that Magritte's hooded figures arouse within us eerily disturbing feelings.

Playing with Fear

Perhaps Magritte is turning over in his grave when he hears these questions. He always protested against any symbolic interpretation of his paintings that might explicitly explain the poetics of mystery. He contrived his works so that they would defy attempts to return them to the realm of the rational and the knowable. In this regard, Magritte strictly adheres to the magician's code: Never reveal the secret of your tricks to the audience. The artist confronts us with our fears and the difficulty we often have in facing them.

Sound Byte:
"People who look for symbolic meanings fail to grasp the inherent poetry and mystery of the image. No doubt they sense this mystery, but they wish to get rid of it. They are afraid. By asking, 'What does it mean?' they express a wish that everything be understandable."

—MAGRITTE

Poetic Strategies

During the first ten years of his mature career (1926–36), Magritte develops most of the poetic strategies that he will rework for the rest

of his career. From now on, he never gives us a single static image (a tuba, for example), but always one in some state of contradiction (such as a *flaming* tuba). His poetic strategy will always include two or more features that achieve their mysterious effect through various forms of poetic association.

Here's a menu of all the poetic strategies to which Magritte constantly returns throughout his career. Even if you only glance at it now and come back to it later, it's **the backbone of his artistic technique** and will be useful to you in really *getting* Magritte's work:

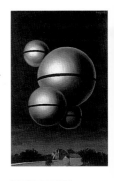

The Flowers of the Abyss. 1928
16 ¼ x 10 ¾"
(41 x 27 cm)

Giraudon/Art Resource, NY

- **Juxtaposition:** He links two (or more) unrelated, everyday objects that, combined, appear somehow strange. Example: the tuba, the valise, and the hooded woman in *The Heart of the Matter* (see page 66).

- **Dislocation:** He puts familiar objects in unfamiliar contexts to evoke a new, unexpected response and a new order of beauty. Example: Sleigh bells float in the sky in *The Flowers of the Abyss* (at right).

- **Hybridization:** He combines two familiar things to make a third, confounding one. Example: A woman's lower body is fused with a fish's head in *Collective Invention.*

- **Metamorphosis:** He "magically" transforms objects—as in fairy tales—from one thing into another. Example: The plants in *Treasure Island* are also birds.

53

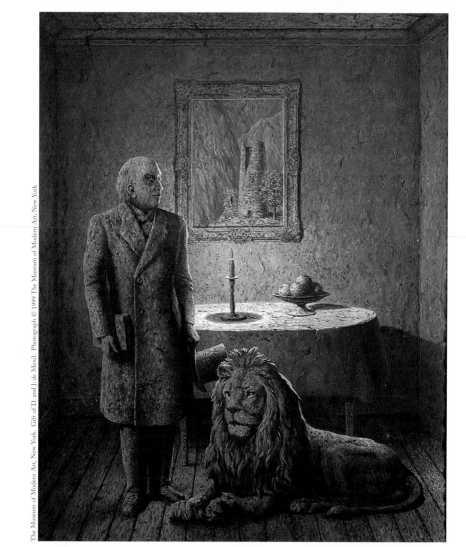

- **Elective affinities:** He juxtaposes two related objects based on affinities or associative relationships between them. Example: In *Elective Affinities* (see pages 74–75), the painting of a giant egg inside a bird cage, the most obvious affinity between the two being a bird.

- **The play of opposites:** (Okay, this is general and incorporates some of the other sleights of hand, but it characterizes some of Magritte's favorite traps and snares.) Two opposite aspects are joined together antithetically. For example, the mysterious luminescence in *The Dominion of Light* (see page 89) is generated by an atmosphere that is both day and night.

- **Fossilization:** He transforms people, animals, words, and things into stone. Example: the stone man, lion, and painting in *Memory of a Voyage* (at left).

- **Animism:** He exploits the uncertainty about whether a "living" thing is dead, or whether an inanimate object is alive. Example: A full-breasted blouse hangs in the closet in *Homage to Mack Sennett* (above right).

- **Doubling:** He duplicates or multiplies objects and

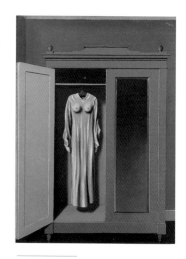

ABOVE
Homage to Mack Sennett. 1937
29 x 21 ½"
(73 x 54 cm)
Giraudon/Art Resource, NY

OPPOSITE
Memory of a Voyage. 1955
63 ⁷/₈ x 51 ¼"
(162.2 x 130.2 cm)

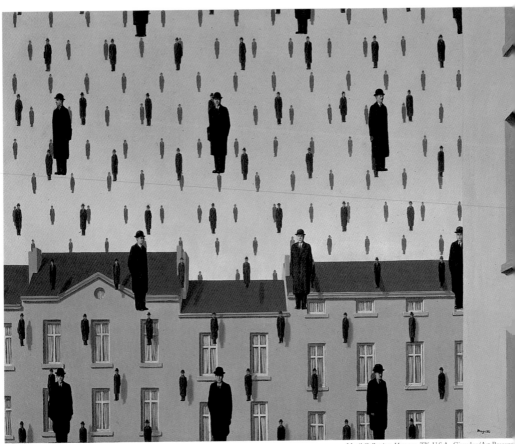

figures, sometimes in the form of a visual pun. Example: Dozens of bowler-hatted men float across the canvas in *Golconda*.

- **Paintings within paintings:** He places paintings within paintings, disrupting our familiar patterns of understanding objects, paintings, and meaning in general. Example: In *The Human Condition* (see page 97), our view of the landscape beyond the window is blocked by a painting that depicts the view of a landscape beyond the window.

- **Words and things:** Perhaps Magritte's most important contribution to art history is his use of linguistic contradiction—i.e., his use of words that contradict or do not necessarily correspond to a designated image. The effect is to loosen the "fixed" mooring between word and image. The classic example is the infamous text, "This is Not a Pipe," written beneath the image of a pipe in *The Treason of Images* (see page 63). Magritte's foray into the linguistic terrain echoes the ideas of Swiss linguist **Ferdinand de Saussure** (1857–1913), whose writings on the connection between language and the thoughts underlying it paved the way to the linguistic theories of Structuralism in the 1970s.

- **Change of scale:** He increases (or decreases) an object's (or subject's) size in relation to its context. Example: A giant green apple occupies the space of virtually an entire room in *The Listening Chamber* (see page 104).

OPPOSITE
Golconda
1953
32 x 40"
(80.7 x 100.6 cm)

57

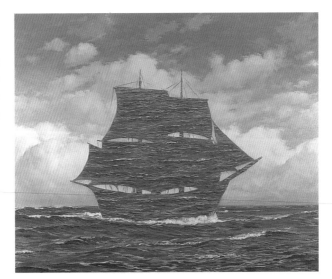

- **Simultaneism:** He merges the contradictory presence of two distinct structures so that both are figured simultaneously. Example: In *The Seducer* (above), the image of a schooner is shaped like a sea vessel but is simultaneously formed by the waves of the sea.

- **Copying:** Magritte imitates the known work of other artists (including his own), modifying it in such a way as to render the familiar image unfamiliar. Example: In *The Balcony of Manet* (at right), he produces his variation of Manet's famous painting, *The Balcony*, substituting coffins for the figures on the balcony.

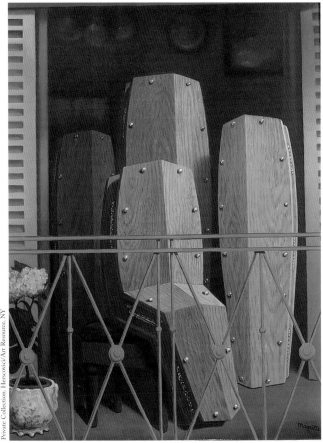

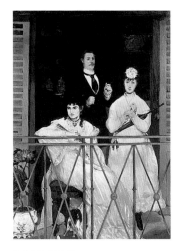

ABOVE
Édouard Manet
The Balcony
1868–69
66 ¹/₂ x 49 ¹/₄"
(169 x 125 cm)

Musée d'Orsay

LEFT
The Balcony of Manet. 1949
31 ¹/₂ x 23 ¹/₂"
(80 x 60 cm)

Sound Byte:

"Surrealist thought is revolutionary because it is relentlessly hostile to all those bourgeois ideological values that keep the world in the appalling condition it is in today."

—MAGRITTE, November 20, 1938

Words and Images

It is during Magritte's time in Paris (1927–30) that he really hits upon one of his most important series: the "Words-and-Images" paintings. In autumn 1927, he makes his first word-painting, *The Interpretation of Dreams*, whose title refers to Sigmund Freud's most important book of the same name. The following features are typical of Magritte's word paintings:

- **The designation of familiar objects with unfamiliar, contradictory names:** For example, in *The Interpretation of Dreams*, the image of a suitcase is accompanied by the word "sky" and the image of a leaf is paired with the word "table." While this method prevails, it is not Magritte's absolute rule. Sometimes the everyday object is designated with its familiar name: He labels the sponge with the word "sponge."

- **The use of brush-script lettering typically found in a children's primer:** The words that accompany each image are written in a

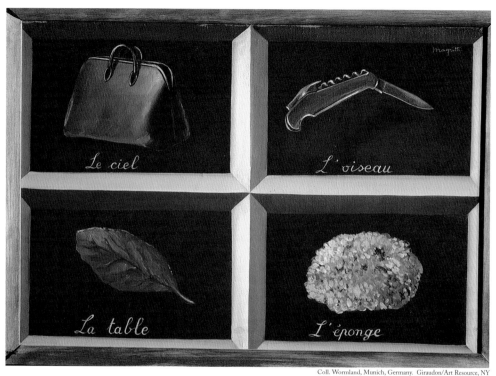

*The Interpretation
of Dreams.* 1927
15 x 21 ³/₄"
(38 x 55 cm)

kind of stylized manner as taught in elementary school; this reflects the Surrealists' interest in the innocence of childhood, in the world of dreams, and in the disruptive promise of art.

■ **The foggy syntax of dreams:** Magritte creates an arbitrary language in which a pipe is not always a pipe and a cigar is not always a cigar. His statement to the viewer is: *Just because you believe this to be a pipe does not mean it is a pipe.*

Sound Byte:
"In a painting, words are of the same substance as images."
—MAGRITTE

This is Not a Pipe

The most celebrated of paintings that incorporates words and images is, without a doubt, *The Treason of Images,* better known by the painting's inscription, "This Is Not a Pipe" *(Ceci n'est pas une pipe).* Beneath the painted image of a pipe, the cheeky Magritte writes in the words, "This is not a pipe." Language is employed to contradict the viewer's habitual response to images, which in this case would otherwise be to say, "This *is* a pipe." The most important thing to look for in these paintings is the way Magritte questions our understanding of the

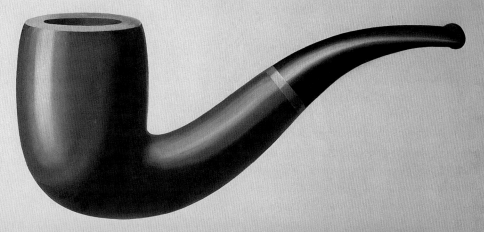

Ceci n'est pas une pipe.

relationship between objects and images and between words and things. Using the interplay between language and images, he seeks to shake up our bourgeois acceptance of status quo and of the unquestioning importance or meaning we give to everyday objects and events.

Between October 1927 and the end of 1931, Magritte produces 42 word paintings. Although he will ultimately produce 22 more word paintings, they are mostly variations and reworkings of ideas he establishes early on.

What is Magritte Smoking?

A little confused, we might ask: *What is Magritte smoking?* Fortunately, he spells out the lessons of his paradox in an article published in *La Révolution surréaliste* in 1929:

- **Lesson number one:** "There is little connection between an object and what represents it." Magritte attacks Platonic assumptions that an *image* of a pipe is identical with the *essence* of the pipe. He thus assaults our habit of saying "This is a pipe" when we see the painted image of a pipe, laying bare the arbitrary relation between the object (in this case, a pipe) and that which represents it (the *word* pipe, or the *painting* of a pipe).

- **Lesson number two:** "An object never fulfills the same function as its name or image." Here, Magritte distinguishes objects from their

representations by reminding us that real pipes have a *useful purpose,* while a painting of a pipe or even the *word* "pipe" does not—a lesson we would easily confirm if ever we tried to smoke one of Magritte's paintings!

That Magritte returns to *The Treason of Images* over and over throughout his career testifies to the importance he places on its concepts. For Magritte, the function of his pipe is more aesthetic than useful: He only enjoys *painting* pipes, not smoking them! (He is, however, an avid smoker of cigarettes, *les noires.)*

Magritte's Titles

The problematic relationship between word and image extends beyond the 60 or so paintings in which words appear. In most cases, the titles of Magritte's paintings complicate the interpretation of images and the understanding of objects. Rather than making the paintings more understandable (which titles generally do), Magritte's titles expand the horizon of meaning and mystify the viewer in much the same way that words do when they appear within the space of his paintings. The misleading title of *The Heart of the Matter* (see page 66), for example, points toward the opposite of the caption's narrative certitude: What could possibly be the heart of the matter in a picture in which a tuba and a valise are juxtaposed with the figure of a hooded woman? Beware of Magritte's titles: *They're often red herrings!*

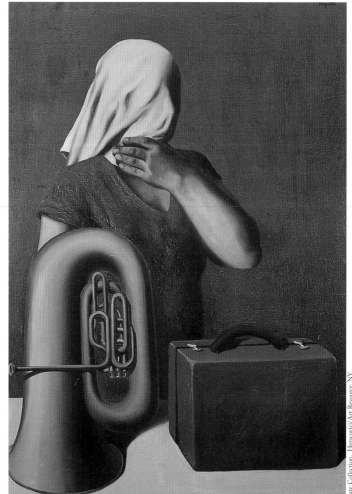

The Heart of the Matter. 1928
45 ¹/₂ x 32"
(116 x 81 cm)

Attempting the Impossible

One of the few childhood recollections that Magritte wrote down is his memory of having come upon a painter one day at the abandoned cemetery in Soignies, where he liked to play. It was here that Magritte made his "discovery of painting." One afternoon, after lifting up the iron gates and entering the underground vaults, he returned to the light of day to find a scene that amazed him. Magritte recalled seeing an out-of-town painter among the broken stone columns and piles of leaves "who seemed to me to be performing magic." He noted that "the memory of that enchanted encounter with painting oriented my efforts in a direction having little to do with common sense."

This sense of the artist as magician is evident in *Attempting the Impossible* (see page 68), Magritte's first self-portrait (though Georgette is also the subject whom Magritte is painting). The theme is a variation on the myth of Pygmalion, who brings to life his sculpture of

67

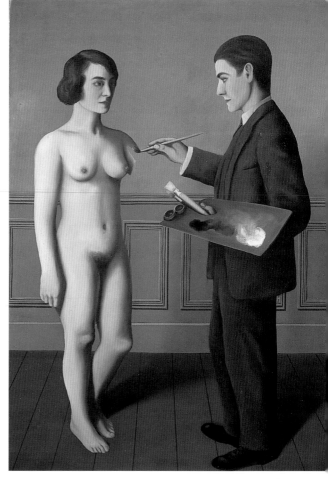

beloved Galatea, with Aphrodite's divine assistance. In Magritte's painting, of course, the painter himself seems to be "gifted with superior powers" as he brings his love to life.

Surrealist Soap Opera

In July 1929, Magritte's contract with his Brussels gallery is terminated (bad news), but Goemans's sales of Magritte's paintings are on the rise (good news: collectors are responding to Magritte's crisper and more polished surfaces) and the dealer plans to show Magritte's work in Paris.

At the recommendation of Dalí (whom Magritte meets when Dalí is in Paris filming the classic Surrealist film, *Un Chien andalou)*, the Magrittes spend the month of August with Dalí at Cadaqués, on the Catalonian coast of Spain, where they rent a house with other Surrealists: Goemans and his mistress; Luis Buñuel (co-director with Dalí of *Un Chien andalou)*; the artist Joan Miró; the poet Paul Éluard and his wife, Gala. The holiday turns into a Surrealist Soap Opera, however, when Gala abandons her husband for Dalí, whom she later marries. Magritte's loyal friendship with Éluard has its roots in these dog days of August.

BACKTRACK:
SIGMUND FREUD
(1856–1939)

If Magritte's on-and-off-again friend, André Breton, is remembered as the great popularizer and proselytizer of Surrealism, then the true intellectual hero of Surrealism is Sigmund Freud, founder of psychoanalysis and author of the seminal work *The Interpretation of Dreams* (1900). In Vienna, Freud pioneered the exploration of the neglected realm of dreams—the unconscious—and of childhood sexuality. Magritte's ambivalence toward Freud (some argue that he rejects Freud altogether) makes Magritte something of an outcast among the Surrealists, who rank Freud among the greatest of modern thinkers.

THE HIDDEN WOMAN, 1929
Photomontage in *La Révolution surréaliste*, no. 12, December 15, 1929

This photomontage of the Paris Surrealist Group surrounding a Magritte painting appears in the important Surrealist review, *La Révolution surréaliste* (No. 12), 1929.

Translation of the text in the painting: "I do not see the (woman) hidden in the forest."

What: The central image is a painting by Magritte in which the figure of a woman substitutes for the word, as in a rebus or children's game. The woman is framed by photographs of members of the Surrealist group with their eyes closed (no peek-a-boo here), each of whom is a contributor to this twelfth issue of *La Révolution surréaliste*.

Theme: Woman as embodiment of mystery (a major Surrealist leitmotif) and the ineffable dance between the visible and the invisible, the knowable and the unknowable.

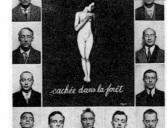

Who: The model for the woman is Georgette Magritte. Surrounding her is the inner circle of the Paris Surrealist group (yes, they are all men): (top row) Maxime Alexandre, André Breton, Luis Buñuel, Louis Aragon, Jean Capuenne; (second row) Salvador Dalí and Paul Éluard; (third row) Max Ernst and Marcel Fournier; (fourth row) Camille Goemans and René Magritte; (bottom row) Paul Nougé, Georges Sadoul, Yves Tanguy, André Thirion, Albert Valentin.

Subtext one: Magritte (at least for now) is a card-carrying member of the Paris Surrealist Group.

Subtext two: The sexual mystery plumbed by Magritte and the Surrealists is definitely male heterosexual desire.

Magritte exhibits in a group show (with Dalí and Yves Tanguy) in Goemans's new gallery, which has the misfortune of opening in October 1929—the same time as the Great Stock Market Crash. In December, Magritte designs the cover of *La Révolution surréaliste*, in which he also publishes one of his most important writings, the illustrated text called *Words and Images*. Ironically, this publication coincides with Magritte's falling out with the Paris Surrealists. At a December dinner party in Breton's apartment, Breton, a notorious bully, asks Georgette to remove the cross she is wearing around her neck. Magritte defends Georgette and they leave in protest. This incident precipitates Magritte's break with the Paris Surrealist Group.

Not a Movable Feast

Magritte discovers that Paris is not always a joyous movable feast. Goemans's gallery folds after his mistress leaves him for the gallery's Dutch backer, thereby cutting Magritte off from his financial support.

He is turned off by many of the Surrealists' methods, such as Breton's *automatic writing* (the purported capturing of unconscious thoughts in words) and Dalí's *paranoiac-critical method*, finding them artificial and premeditated. Down and out in Paris, he and Georgette pack their valises again and return to Brussels in July 1930. His tempestuous relationship with the Paris Surrealists will continue on and off throughout his life.

Return to Commercial Art

To make ends meet back in Brussels, Magritte opens **Studio Dongo,** an advertising and publicity firm he runs out of his backyard shed with the business assistance of his brothers, Paul and Raymond. Although he claims to loathe advertising, Magritte produces a significant number of **posters and advertisements** (cigarettes and alcohol, for example) and creates the art for musical scores (of which some 60 are known today). Unlike his earlier commercial work, which had been produced for art-loving clients and in which he had taken some pride, these designs are created for a more general public and, therefore, are conceived with more compromise and less art. As Magritte puts it, "The only problem is that, for the public, it is absolutely necessary to have mediocre things. It is only on very rare occasions that one may hope to have a remarkable idea accepted."

Because of these commercial art activities, Magritte's output dwindles over the next four years (from mid-1930 until the end of 1934) to fewer than 50 oil paintings and 12 gouaches. Paradoxically, it is not Magritte's advertising posters but his Surrealist paintings—his *fine* art—that have exerted an unparalleled and extraordinarily pervasive influence on late-20th-century advertising and popular culture.

Magritte's Politics: *No* to Fascism

Like many of the Surrealists, Magritte sympathizes with leftist

*Tonny's Toffee
Antoine.* 1931
Poster lithograph
10 $^3/_8$ x 17 $^4/_5$"
(26 x 45 cm)

struggles his entire life. *Recall:* In 1934, Hitler had assumed power and the tide of Fascism was on the rise. In response, Magritte edits and contributes a powerful anti-Fascist tract to the Belgian review *Documents* in 1934, calling for "immediate action" against Fascist oppression. Further, he designs propaganda posters in the late 1930s for The Vigilance Committee of Anti-Fascist Intellectuals, the Communist Party, and the Belgian Textile Workers Union. Plus, he joins the Communist Party in 1945, even though he is too much of an individualist to remain a member for long. He does, however, remain

ELECTIVE AFFINITIES, 1933
16 x 13" (41 x 33 cm)

Collection E. Perier, Paris

What: Magritte invents a new method for composing images based on affinities or associative relationships between objects—the most obvious affinity between the cage and the egg being a bird. This discovery leads to an important change in the direction of Magritte's work: From here on, almost all of Magritte's objects are identifiable.

Confinement: The cage and the egg are both structures of confinement. Note the shallow, Magrittean space in which close-up planes really put the egg in the viewer's face.

Change of scale: Magritte changes the egg's familiar relationship to its context by dramatically enlarging it.

The artist speaks: "One night, I awoke in a room where a cage and the bird [Georgette's canary] sleeping in it had been placed. A magnificent error caused me to see an *egg* in the cage instead of the bird. I then grasped a new and astonishing poetic secret, because the shock I experienced had been provoked precisely by the affinity of two objects, the cage and the egg, whereas previously, I used to provoke this shock by bringing together objects that were unrelated."

The title: The name of the painting comes from an 1809 novel by the German Romantic writer, Johann Wolfgang von Goethe (1749–1832).

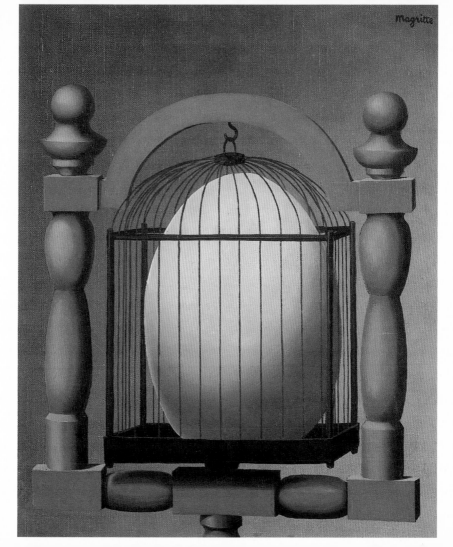

sympathetic to Communism his entire life. What's more, he refuses to lose his fairly pronounced Walloon accent (a regional dialect), since he considers it a barometer of his own class-consciousness and of his particular Belgian identity.

Magritte Copies Himself (and Others!)

Magritte begins to produce more paintings in 1935, encouraged by an avid collector and by the prospect of a one-artist exhibition in New York at the innovative Julian Levy Gallery. With America in mind, he produces several replicas and variations of earlier works, including *The Discovery of Fire* and the English version of *This Is Not a Pipe*. (Not a single painting from this exhibition finds a buyer, unless we count Levy's customary purchases.)

Magritte almost never copies paintings stroke for stroke. He generally changes the scale or varies the composition. But his willingness to rework previous themes incites his critics to charge him with lacking inventiveness and submitting to the demands of the market, just as Dalí and the late de Chirico were accused of doing.

Fast forward: Since the 1960s, as Magritte's reputation continues to rise, it is clear that his original critics didn't understand what the idio-syncratic artist was about. Bear in mind that in Europe the dominant art of the 1930s, 1940s, and 1950s was *abstract art*. Abstraction's crowning achievement was Abstract Expressionism (Jackson Pollock,

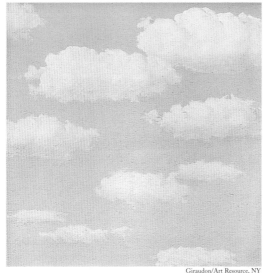

The Sky
(aka *The Curse*)
1941

Willem de Kooning, et al.), with heroic canvases and free brushwork that made Magritte's painting appear (to some critics) as small-scale, illustrational, and, worse yet, "inartistic." Magritte was not out of step with abstract painting; it's just that the only army he marches with is his own!

Those dreamy, cloud-filled Skies: Magritte's Bread & Butter

The years prior to and including World War II are financially difficult for the Magrittes. One of the types of paintings he knocks off more

than a few times to earn extra money are his miniature versions of *The Sky,* also entitled, delightfully, *The Curse,* since the cheery blue skies and puffy clouds made him scowl. (He had already made more than a dozen of the large-scale versions in 1929–31.) These *trompe l'oeil* paintings depict dreamy white clouds floating across a blue sky, which we might refer to now as a Magrittean sky. Like *The Dominion of Light* series, *The Sky* is one of the few compositions that Magritte does not noticeably alter using his bag of Surrealist tricks, except perhaps for cropping—hardly a technique unique to Surrealism. (Note: When Magritte reworks pre-existing themes, he often gives all the works in the series the same title, whether he makes the paintings in the 1930s or 1960s. This is unusual for artists, who are expected to create original works. Just as Magritte provokes and thumbs his nose at collectors who value art for its uniqueness and originality at the time, he continues to befuddle art historians and art lovers over the trajectory of his artistic "development.")

Time keeps on Slipping, Slipping, Slipping...

Magritte spends a fair amount of time in London in 1938. His first visit—for a major Surrealism exhibition—is followed by a longer trip for a retrospective of his own work at a gallery run by Mesens. While staying at the home of one of his collectors, **Edward F. W. James** (1907–1984), godson of King Edward VII, he paints what will become one of his most widely reproduced images, *Time Transfixed,* the

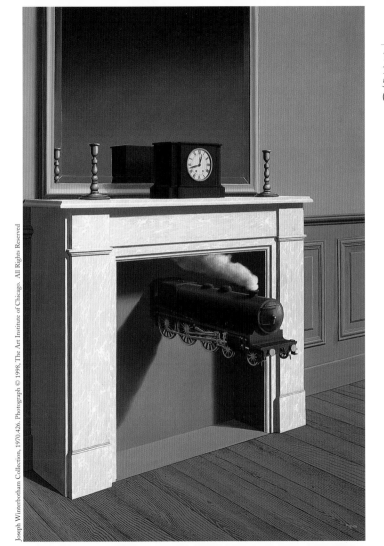

Time Transfixed
1938
58 $^3/_8$ x 39 $^1/_8$"
(147 x 98.7 cm)

painting in which a steaming locomotive emerges from the mouth of a dining-room fireplace. The train is shown, as Magritte indicates, "in place of the usual stove-pipe," which at the time is commonly found in London fireplaces, such as the one in James's apartment.

Although Magritte usually creates his images only after an elaborate process of invention assisted by drawings, this image apparently comes to him immediately. It evokes wonder and puzzlement in the viewer, however, because even when we understand its elective affinities—its intended associations—we are willingly transported to an enchanted domain.

War Breaks Out

The timing of historical events outside of Magritte's control continues to be bad for the Belgian. On the heels of good success with solo exhibitions in New York, London, and Brussels, war breaks out in 1939. It's like a rerun of ten years earlier, when the stock market crashed and Goemans's gallery folded. To help out with their finances, Georgette begins working at the artist's supply store where Magritte buys his supplies (she gets him a discount!) and continues to work until the mid-1950s, even after Magritte's commissions have increased substantially.

In response to the German occupation of Belgium in 1940, Magritte flees to Carcassonne, in southern France, with his friend, the lawyer and writer **Louis Scutenaire** (b. 1905). Curiously, Georgette stays

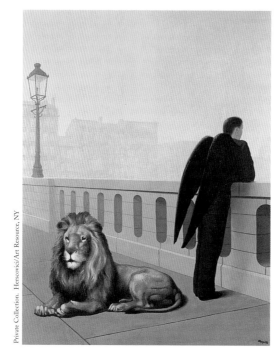

Homesickness
1940

Private Collection. Herscovici/Art Resource, NY

behind. Given the context, his choice of the title *Homesickness* seems uncharacteristically straightforward. The lion—a figure often recycled by Magritte from his lexicon of childhood images—appears before a suit-wearing angel that casts its gaze across what appears to be a French bridge. Is he thinking of Georgette back home in Belgium? Does the second German invasion of Belgium remind him of the

81

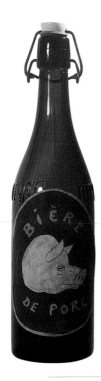

"Pork Beer." 1937
Painted bottle
(77.5 x 35 x 19.3 cm)

Coll. Christine Brachot, Brussels
Belgium. Herscovici/Art
Resource, NY

horror and displacement that followed shortly after his mother's death?

The Painted Bottles

After three months in Carcassonne, Magritte returns to the deprivations of occupied Belgium, where it is increasingly difficult to pay for art supplies, even with the discount Georgette gets for him. Since canvas is scarce (and therefore expensive), he earns a little extra bread and butter by painting wine bottles on demand for sympathetic collectors. He had painted the delightfully satirical *Pork Beer* on a beer bottle in 1937, and now Edward James encourages him to paint more bottles, suggesting that "it's New York taste exactly, and Hollywood's too." The war prevents this market from being exploited, however, and most of the bottles are commissioned by local collectors or given away as gifts to friends. **About 25 painted bottles are known today,** painted mostly on Bordeaux and Burgundy bottles. Some incorporate reworkings of Magrittean themes—such as the trademark cloud-and-sky motif and the flying bird in a mysterious sky (the image later adopted as the logo of Sabena Airlines)—whereas others, like *Pork Beer,* are unique motifs. The most frequent subject of

the painted bottles is a nude woman whose body shape follows the contours of the bottle. (Some of these are titled *Woman-bottle.)* The bottles now sell at auction for hundreds of thousands of dollars.

Breaking with his Familiar Style: 1943–48

An invitation announcing Magritte's 1943 exhibition in Brussels heralds the astonishing news that "René Magritte has broken with his usual technique." These aberrant and quirky works, which deviate from Magritte's typical Surrealist illusionism, consist of two distinct bodies of work:

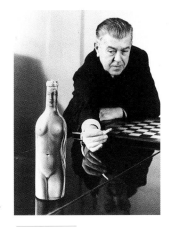

Magritte with painted bottle 1961

- **"Surrealism in the Sun"**: a.k.a. Magritte's "Renoir" or "Impressionist" period (1943–47)

- **The "Vache" period**: Garishly colored, cartoonlike paintings created during a period of only a few months (1947–48).

Important: At no time does Magritte completely abandon his mature style (which he later calls "the Magritte of yore"). He paints a number of canvases during these same years in his usual manner.

Surrealism in the Sun

The expression "Surrealism in the Sun" is Magritte's reference to the 19th-century Impressionist painters of light who practiced their art *en plein air* (i.e., outdoors). It is also the title of a manifesto he publishes in 1946 that triggers a volatile dispute among Surrealists over whether or not the Impressionist technique can be reconciled with Surrealist imagery. Magritte's total output of "Surrealism in the Sun" art is about 70 oils and 50 gouaches.

Sound Byte:
"Since the beginning of this war, I have a strong desire to achieve a new poetic effectiveness which would bring us both charm and pleasure. I leave to others the business of causing anxiety and terror."
—MAGRITTE, in a letter to Belgian artist Pol Bury, 1945

"Surrealism in the Sun" brings **new energy** to Magritte's "systematic search for a disturbing poetic effect." It's sometimes called his "Impressionist" period because of the obvious use of Impressionism's pleasing brushstrokes, bright pastel colors, and insipidly pleasant imagery. Magritte's debt to Renoir is obvious in *The First Day*. According to Magritte, these "always-look-on-the-bright-side-of-life" works **are a reaction against the hardship and horrors of the German Occupation,** which causes severe food shortages and low morale in Brussels.

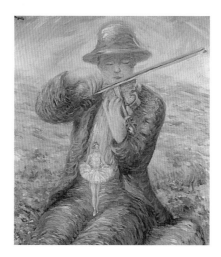

The First Day
1943
23 ³/₄ x 21 ³/₄"
(60 x 55 cm)

Private Collection
Giraudon/Art Resource, NY

Magritte's Revenge: Mooooooo!

For another unorthodox encore, Magritte conjures up his **Vache pictures,** setting aside his earlier style one more time for a quirky, near-Expressionist palette of garish, **vivid colors** and loose brushwork that depict quirky, **cartoonlike scenes of absurd imagery** that is caricatural. But there is no Expressionist angst in these pictures. They wallow joyfully in the iconographic muck of cartoons, mounting a "low," comic assault on serious or "high" art. By giving them the name "Vache" (French for *cow)*, Magritte has fun with the term *Fauve,* or "wild animal," used to describe the style of Matisse and his circle of friends about 40 years earlier. *The Ellipsis* is typical of his brash, idiosyncratic Vache works, of which there are only about 15 oils and 10 gouaches.

TOP
The Cripple
1948
23 ¾ x 19 ½"
(60 x 50 cm)

Private Collection
Giraudon/Art Resource, NY

BOTTOM
The Ellipsis
1948
19 ¾ x 29"
(50 x 73 cm)

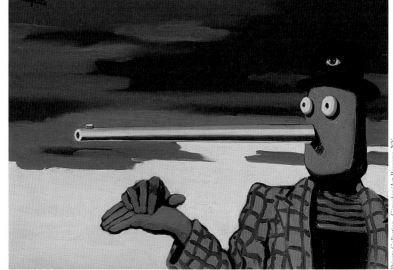

Private Collection Giraudon/Art Resource NY

Finally, a Solo Exhibition in Paris

The Vache works are produced explicitly for Magritte's first one-artist show, to be held in Paris at the Galerie du Faubourg. This makes him the last major Surrealist painter to have a one-person exhibition in Paris. Magritte does not try to impress the Parisians (with whom Belgians share widespread mutual antipathy).

He does not polish up the favorites—one of his old pipes or something similarly appropriate. Rather, in a move that bears out his still-lingering Dada spirit, Magritte goes Vache and exacts revenge on the Paris art world—revenge for the meager attention it has paid him over the years, revenge for its vocal rejection of his "Surrealism in the Sun" works, and revenge for all its high-art pretensions.

Last Laugh

So who gets the last laugh? Magritte's first Paris exhibition, as might be expected, is a massive critical failure. Not one painting sells. After telling the Parisians "to step in it," he abandons the colorful Vache series and returns quietly to his familiar "well-made pictures of yore," apparently at the request of Georgette. Although brushstrokes from the Impressionist period occasionally re-emerge in his paintings, Magritte leaves these jewels behind for latter-day audiences "to step in" and to decide for themselves.

Les Chants de Maldoror

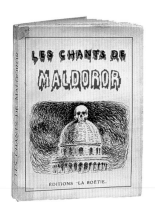

In 1948, seventy-seven of Magritte's wonderfully strange pen-and-ink drawings are published in a new edition of *Les Chants de Maldoror,* a novel-length prose poem by the 19th-century French writer **Le Comte de Lautréamont** (1846–1870), which the Surrealists worship as a Bible. It is a darkly absurd and sadistic poem of bizarre psychological power that no doubt was well thumbed by Magritte. As art historian Suzi Gablik points out, its iconography of dislocation, amputation, decapitation, fragmentation of human flesh, somnambulism, putrefaction, vegetalization, and metamorphosis suggests analogies with Magritte's imagery.

Lautréamont's *Les Chants de Maldoror.* 1948 Engraving/book cover

Private Collection
Giraudon/Art Resource, NY

Drawings—such as the ones he does for *Les Chants de Maldoror*—are an important part of Magritte's working method. They play a significant role in the development of his images and themes. Magritte is particularly attracted to the greater spontaneity of drawing, which allows him to make fortuitous new discoveries of unthought-of images.

Let There Be Light

Between 1949 and 1964, Magritte produces 16 variations of *The Dominion of Light* in oil and 10 gouache versions. No other image sells as well during his lifetime.

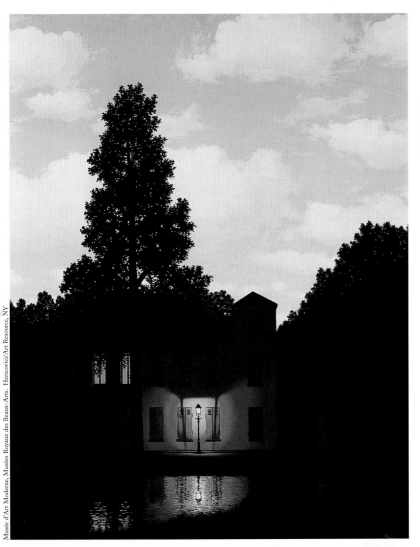

*The Dominion
of Light.* 1954
58 x 45 ¹/₄"
(146 x 114 cm)

Compositionally, it is Magritte at his most conventional: This world of light is as close to the one we live in as Magritte ever comes. Why is it, then, a classic Magrittean success? Well, as you might guess by now, he once again makes the familiar unfamiliar, and he reconciles opposites. Although we might be tempted to praise Magritte's convincing technical illusionism, these paintings succeed because they destabilize the relationship between familiar and unfamiliar. The *strange*, in Magritte's world, almost always begins with something familiar. What could be more familiar than the image of a home? The Surrealists in general (and Magritte in particular) love this device. What amazes us is the effect of the contradictory light sources that simultaneously evoke both night and day. Neither dominion of light—either of nature (the luminous sky) or of culture (the lamp-lit home)—seems to prevail. Rather, we are transported to an uncertain domain of mystery.

Sound Byte:
"The landscape suggests night and the sky suggests day. This evocation of night and day seems to me to be endowed with the power to delight and surprise us. I call that power—poetry. This great interest in night and day is a feeling of admiration and amazement."

—MAGRITTE

Large-Scale Commissions

For a change of pace, Magritte creates four large murals between 1951 and 1961. These projects are undertaken as commissions, providing him with income and recognition during years when his paintings are not fetching high prices. Magritte is said to have painted his familiar cloudy blue sky motif himself for the ceiling murals at the Théâtre Royal des Galeries Saint-Hubert in Brussels (1951), one of which is illuminated by a gigantic chandelier. (Magritte's skies, charming here, have devolved into artless interior decoration elsewhere in the imitations by lesser *artistes.)*

OVERLEAF
The Enchanted Domain, panel VI
1953

The Surrealists love games of chance, and Magritte revels in the idea of the site of his second mural—a casino in Knokke-Heist, on the Belgian coast. *The Enchanted Domain* (on the following pages) is the most ambitious in scale of Magritte's murals: Its circumference of 72 meters (238 feet) wraps around the casino's main gaming room in a spectacular manner.

Magritte's third mural, *The Fairy Who Knew Nothing,* is executed at the Palais des Beaux-Arts in Charleroi, the cultural center of the region where he spent most of his childhood. The title of his final mural at the Palais des Congrès in Brussels, *Mysterious Barricades,* may reflect the awkward space allocated to Magritte by the Belgian Ministry of Works. Magritte's final three murals are known for their **monumental scale** (in contrast with his usual, small-scale format),

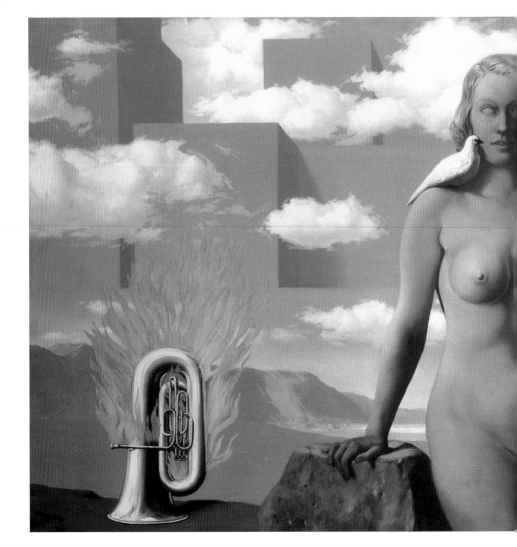

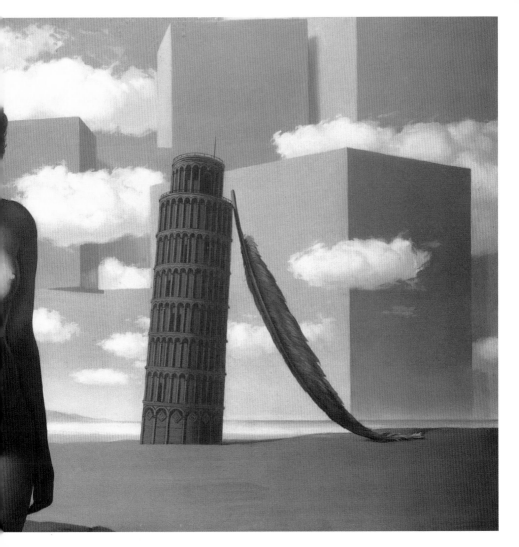

their **reorganization of images** drawn from the artist's catalogue of better-known works (thus creating a panoramic spectacle of Magritte's greatest hits), and for the **collaboration of assistants** who execute the works on location based on Magritte's own drawings and plans. He sometimes permits the assistants to use mechanical transfers—an act that anticipates one of the crucial aspects of Conceptual Art of the 1960s, which values concept over craftsmanship.

Are these Magritte's greatest works? Absolutely not. Technically successful, the scale and recycling of images transport the viewer into a world more like a Magrittean theme park than an enchanted domain. He does them for money and for the local prestige they confer upon him.

Paintings within Paintings

Have you noticed the **large number of windows** in Magritte's paintings? He loves to play with the idea of **painting as window,** with the picture plane as window onto the world. As we have since learned, he brings us "visions glimpsed between sleeping and waking" by disrupting the familiar world order with a variety of techniques designed to create contradiction on the canvas. He uses one of these—the painting within a painting (a device he learned from de Chirico)—to dissolve the frames that mark the distinctions between inside and outside, between "real space" and represented space. The paradox is delightfully simple in *Where Euclid Walked* (see page 96): A painting placed on an easel

blocks our view onto the exterior landscape. But is the cityscape in the *painting within the painting* identical to the view from the window? What is real and what is "represented?" Once again, Magritte's painting turns on its head the familiar order of things, assaulting our habits of seeing and the way we understand objects and paintings.

Sound Byte:
"Visible things always hide other visible things."
—MAGRITTE

The title, *Where Euclid Walked,* refers to the famous Alexandrian mathematician Euclid (c. 300 B.C.), to whom Magritte himself makes a punning reference in the geometric mirroring of the tower's cone (a foreground "presence") and the perspectival cone of the road within the painting that vanishes into the horizon. Magritte values these optical illusions, as we see in works such as *The Human Condition* (see page 97): They induce a sudden shock or panic in the viewer.

Magritte's Amateur Films

A number of Surrealists, Magritte included, experiment in the medium of film. He makes a short film in 1930 and collaborates on another two shot by his friend, Paul Nougé (all are now lost). Magritte's most

Where Euclid Walked. 1965
64 ¹/₈ x 51 ¹/₈"
(163 x 130 cm)

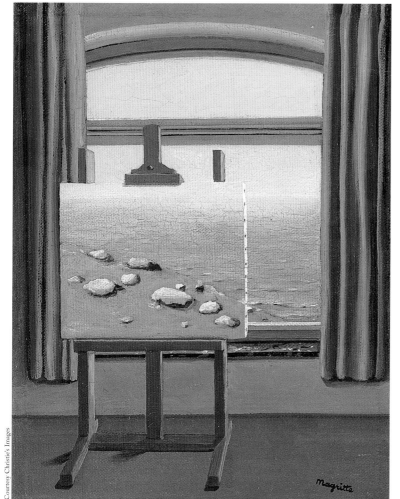

The Human Condition. 1934
10 x 7 ⅞"
(25.5 x 20 cm)

more personal genre of amateur film, of which he makes some 40 or so between 1956 and 1960. Filmed in handheld black-and-white and color 8mm and Super 8, Magritte's films (all silent) are unstaged, unedited, often unscripted, and technically conventional. Never originally intended for public reception, they are homemade, do-it-yourself productions generally created in playful collaboration with Georgette and close friends. Some of the images in the films mirror Magritte's more memorable painted images, such as a flaming tuba or two hooded figures kissing. More than anything else, however, *the amateur films reflect the artist's pursuit of the spirit of play* and dedication to collective invention. Like his own amateur films, Magritte's taste in film is more middle-class than avant-garde: He owns a collection of Charlie Chaplin's silent films and also enjoys war films and westerns, particularly those of John Wayne.

A Day in the Life of René Magritte

A typical day in Magritte's life is uneventful, at least from outside appearances. It consists of regular habits, such as walking his Pomeranian dog, Loulou, to the store to buy groceries, or spending the afternoon with

Magritte's house at 97, rue des Mimosas, Brussels

This is a Piece of Cheese. 1963–64
Oil on masonite
(under glass dome)
4 ²/₅ x 6 ½"
(11.1 x 15.1 cm)
in gilded wooden
frame

friends, perhaps at the Greenwich Café, where he sits for hours with the chess players. On Saturdays, Magritte and his Belgian Surrealist friends regularly gather salon-style.

His younger friend, Marcel Mariën, recounts the story of going to the grocer's one day with Magritte to buy some Dutch cheese. After the shopkeeper bends over the window display to pick up a round of cut cheese, Magritte stops her: "No, Madame. Not that one. Give me some of the other one instead" (pointing to a second round of cut cheese not far from the first). "But it's the same cheese!" exclaims the grocer. "No,

THE SON OF MAN, 1964
45 ⅝ x 35" (116 x 89 cm)
Private Collection. Giraudon/Art Resource, NY

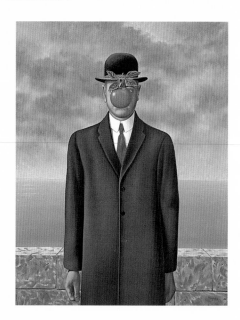

What: Magritte as the bowler-hatted man. One of only four oil self-portraits that Magritte identifies as self-portraits and the only painting in which he explicitly identifies the bowler-hatted man with himself.

Why: Magritte paints it for one of his most important collectors, Harry Torczyner, who commissions it. After Torczyner's death in 1997, the painting sold at the 1998 Christie's auction for $5.3 million to an unidentified American collector bidding by telephone.

Subject: A floating green apple conceals the face of a bowler-hatted man (yes, it is Magritte!) standing under a stormy sky before a waterfront. As always, the horizontal stone wall behind the man keeps the space shallow and perspective immediate.

Speculation: Although Magritte vehemently objects to any symbolic interpretation of his paintings, art historian David Sylvester notes that "the fact is that the objects he chose to attach to the bowler-hatted men are often irredeemably symbolic objects. The son of man has the symbol of the Fall before his eyes."

Madame," Magritte insists, "the one in the window has been looked at all day long by people passing by." In his everyday life, as in his art, Magritte casts the most commonplace, quotidian things in an unsettling and unfamiliar light, which points toward hidden and new ways of seeing the world.

Magritte's friend and lawyer during the later years of his life, Harry Torczyner (d. 1997), describes Magritte as curious, voyeuristic, analytical, often negative, opinionated, and willing to confront those "who attempted to impose the conventionalities upon mankind." He also describes Magritte as a shy, solitary man, and as a hypochondriac who likes neatness and is on time for appointments.

Georgette and the Objects of Bourgeois Desire

Magritte defers to Georgette's taste in home furnishings, which, at least in the later years, includes department store antiques, sofas, armchairs, Oriental rugs, and a baby grand piano. Ironically, her taste borders on Pop esthetics. Harry Torczyner recalls strolling with Magritte one day in Nice (France) in 1964, when the

artist spotted a porcelain rooster: "I must buy that for Georgette," Magritte told him. "Are you still courting her, René?" Torczyner asked. "It's true," Magritte replied, smiling.

Is "The Painter of Objects" the Godfather of Pop?

Magritte's international recognition and fame emerge in the 1960s at the same time as the rising fortunes of Pop artists who claim a kinship with him. Some even claim Magritte as the Father of Pop. Jasper Johns, Roy Lichtenstein, Robert Rauschenberg, and Andy Warhol all acquire works by Magritte. The crowning achievement of Magritte's international *pop*-ularity is the 1965 Magritte exhibition at The Museum of Modern Art in New York. The Pop artists' admiration, however, is not returned by Magritte, who finds Pop—its soup cans and Coke bottles—too accepting of the contemporary world. "Something rather miserable inspires them," Magritte remarks in 1964, adding: "I myself think the present reeks of mediocrity and the atom bomb."

Sound Byte:
"The humor of Dadaism was violent and scandalous. The humor of Pop Art is rather orthodox; it's within the reach of any successful window-dresser. Are we permitted to expect from Pop Art anything more than a sugar-coated Dadaism?"

—MAGRITTE, appearing on Belgian television in 1964

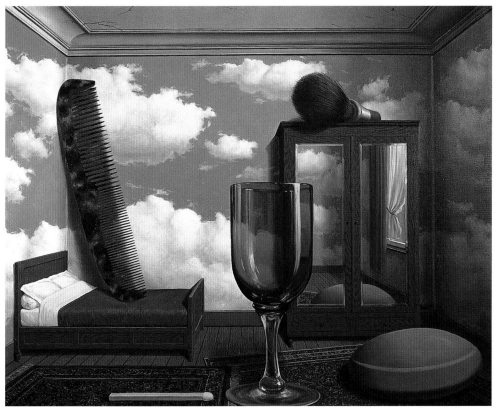

Personal Values
1952
31 ⁷/₈ x 39 ³/₈"
(81 x 100 cm)

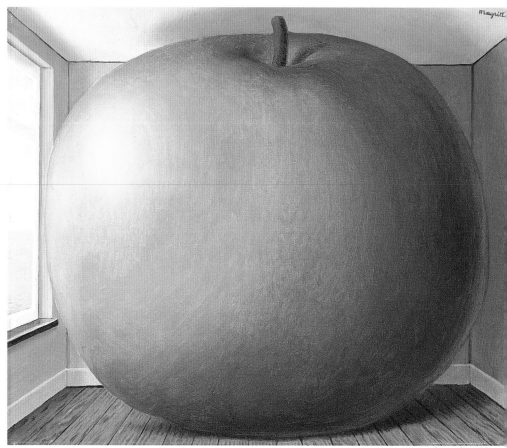

magritt

been expected to fetch between $2.5 million and $3.5 million.)

- **Changes of scale:** Although this is not a new device for Magritte, there are two great examples, *The Listening Room* and *The Wrestlers' Tomb* (see page 106), in which a familiar object (a giant green apple and a giant red rose, respectively) are dramatically enlarged in relation to the scale of the room each occupies.

- **Magritte's luxurious indulgence in bright pigments:** Although bright colors are not typical of most of Magritte's major works (except for the brief Impressionist and Vache periods), his palette does brighten from time to time in later years, most strikingly in *The Listening Room* and *The Wrestlers' Tomb*. This element would have appealed to a number of Pop artists who also experimented in bright and Day-Glo colors.

- **Pictorial wit:** This is the manner in which the framing of an object can dislocate it from the world, rendering its meaning arbitrary, as in *The Interpretation of Dreams,* which is organized by a windowlike frame. (Pop artist Jasper Johns owns a 1935 version of this picture.)

Although the prominence of Magritte's fame coincides with the rise of Pop Art, Magritte never shares Warhol's wish that everyone be "famous for fifteen minutes." On the contrary, Magritte never seeks the fame that comes to him late in life and which, as his friend Scutenaire points out, makes Magritte "more tormented than he [has]

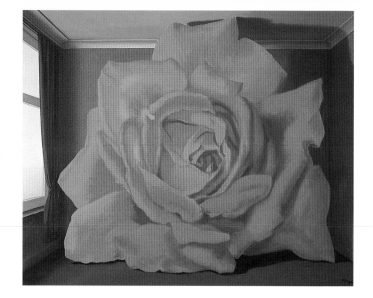

The Wrestlers'
Tomb. 1960
35 x 46 ⅛"
(88.20 x 116.42 cm)

Private Collection
Giraudon/Art Resource, NY

been by incomprehension and misunderstanding. The more honors—
and money—he receive[s], the more uneasy he [feels]."

Other Influences: Then and Now

If Magritte's paintings of objects influence the Pop artists, it is his
linguistic understanding of art (his notion that in a picture "words are
of the same substance as the images") that influences the development
of another major 1960s art movement—Conceptual Art—popularized
by a less commercially driven group of artists who share Magritte's
priority of idea over painting and its execution. Internationally

acclaimed Conceptualist artists, such as the Belgian **Marcel Broodthaers** (1924–1976) and the American **Joseph Kosuth** (b.1945), explicitly acknowledge the importance of Magritte's work to their own pioneering investigations, and even recycle his imagery in their own work.

In the 1990s, it became increasingly difficult to speak about contemporary art without invoking the name of Magritte, whose umbrella of influence continued to grow as major 1990s artists, such as **Robert Gober** (b. 1954), continued to rummage through the leftovers of Surrealism and Conceptual Art.

The Sculptures

Shortly before his death in 1967, Magritte is encouraged by his dealer, Alexandre Iolas, to have a go at making sculpture for the first time in his career. The plan is to create three-dimensional sculpture based on images borrowed from existing paintings and to produce the sculpture in the traditional (and market-friendly) medium of bronze. Unlike paintings, sculpture can be viewed in the round.

Magritte visits the foundry near Verona, Italy, in June 1967, where he signs eight wax models to be used to cast the bronze sculptures. Shortly after returning to Belgium

La Joconde (Mona Lisa)
1967. Bronze
97 ¹/₂ x 69 ¹/₂ x 36 ¹/₂"
(250 x 177 x 97 cm)
Giraudon/Art Resource, NY

around the end of the month, however, he becomes ill. After spending a short time in the hospital, Magritte dies at home on August 15, 1967, from cancer of the pancreas. He never sees the realization of the bronzes, some of which are table-size, others furniture-size. Notes and drawings left behind by the artist show that for at least one sculpture, *La Joconde,* it was his plan to paint one of the curtains with his trademark clouds-and-sky motif.

So are the sculptures, in fact "completed" works? Magritte's dealers clearly thought so, seeing fit to exhibit them the following year in Brussels and London (1968) and again in Zurich (1972). Still, they have attracted little serious critical attention. The bronze medium of these luxurious sculptures is too loaded with the gravity of valuable art trophies: It weighs down the ethereal "ascendancy of poetry" that mystifies us so effortlessly in their two-dimensional predecessors.

Last Words

One of Magritte's final works is the prophetically titled, *The Last Word* (see page 112). Against a background of dizzying mountains depicted in many of Magritte's paintings, we see a large, floating leaf that contains the image of a tree. Magritte's placement of the tree (the whole) within the leaf (a fragment of the whole) confounds us once again with a contradictory vision of the impossible. *The Last Word* summons up the abyss that lies below the tree of life. It is the gap

between objects and images, words and things, life and death. Perhaps this invisible unknown will always escape those who seek to apprehend it, as the Belgian Master of Surrealism surely did. "Our only duty," Magritte implores us, "is to try to grasp this enigma."

So Why is he Great?

Defiant of status quo and of all received ideas, especially those that deal with what it means to be a painter and artist, Magritte takes great pleasure in defying expectations and efforts to categorize him and his work. Unlike the heroic, protean Picasso—the archetypal modern artist whose achievement is measured by stylistic evolution (e.g., Blue Period, then Rose Period, then Cubism, etc.)—Magritte enjoys confounding the tidy, heroic narratives that art historians love to concoct. Although informed by an avant-garde sensibility, he paints in a style (illusionism) that, for most modern painters and their champions at the time, is considered academic and out of step with prevailing trends of abstraction.

Sound Byte:
"The idea of manipulating paint makes me feel rather sick."
—MAGRITTE

What's more, Magritte sticks with illusionism his entire career (with two brief exceptions), focusing not on *how* to paint but rather on *what* to paint. In terms of pictorial invention, he defies a linear, continuous narrative. *Most of his major themes and pictorial problems are developed within the first ten years of his mature career (1926–36),* so it is not unusual for him to rework a theme in the 1960s that he first developed thirty years earlier, varying it in such a way that it is often more compelling than the original, earlier one.

Like Matisse and Picasso, Magritte forces a radical change of the relationship between the viewer and the art. Rather than making "disinterested" paintings for aesthetic enjoyment, Magritte aims to provoke, surprise, and shock his audience. He abandons traditional notions of beauty and the sublime in favor of the aesthetics of the uncanny and the mysterious. Although widely misunderstood from the beginning of his career, Magritte is the most durable and accessible of all the Surrealist painters. This is largely because he draws from a lexicon of **the commonplace and the familiar**—things from the world we recognize—to conjure up **a world of surprise.**

His refusal to include fantasy imagery in his mature art sets his work apart from that of the other Surrealist painters. Moreover, in his scorn for the swirling, opaque surfaces of abstract painting that read as a giant Keep Out sign to so many viewers of modern art, **Magritte teaches us how to look at life's private mysteries,** at the inexpressible moments and

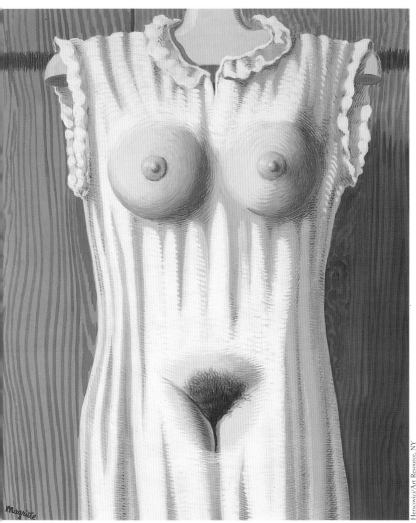

The Philosophy of the Bedroom
1966

The Last Word
1967
32 $^1/_8$ x 25 $^4/_5$"
(81 x 65 cm)

sensations we all feel. His canvases are worlds into which the viewer can enter, in part because **Magritte is preoccupied with thoughts, poetry, and philosophy more than with the act of painting itself.** He considers himself a thinker who happens to paint.

Today's viewers are no longer shocked in the same way and with the same distress that viewers once were at the original, early reception of Magritte's paintings, when they were widely rejected and discredited. Although fame and success arrived late in Magritte's life, his reputation and influence continue to grow. If the Magritte we now admire is idiosyncratic, anti-conventional, and delightfully puckish, his paintings—his lucid dreams—are astonishingly accessible and relevant today. We value them for their ability to evoke mystery in an increasingly ordinary world. They remind us of the latent potential of the imagination and of the promise that imagination might play a vital role in conceiving the world in new ways.